G000044414

CONTENTS

ACKNOWLEDGEMENTS

This book would not have been possible without the work of the many people who have contributed to and documented the official records of Warrington's part in the First World War and all those who have generously shared the stories of their family's or community's contribution.

Particular thanks are due to the staff of the town's Local Studies and Archives section and especially Philip Jeffs and also to Cheshire Record Office and for their support. A wide variety of original sources have been consulted including the archives of the *Warrington Guardian* and other contemporary newspapers, diaries, posters, pamphlets, company archives and other memorabilia. All images are from the collections of Culture Warrington apart from those images in chapters 2, 3 and 5 marked ©LIM which appear courtesy of the Duke of Lancaster's Regiment and the Lancashire Infantry Regiment.

Every effort has been made to trace the copyright holders of other photographs and Culture Warrington acknowledges the work of the contemporary photographers whose work helps brings Warrington's story of the First World War to life today. This book could not hope to detail every aspect of Warrington's war and there are many fascinating stories and images which were reluctantly omitted. However, Culture Warrington hopes this volume will encourage many others to add to the official archive of Warrington's role in the First World War.

CHAPTER 1

WARRINGTON IN THE PRE-WAR YEARS

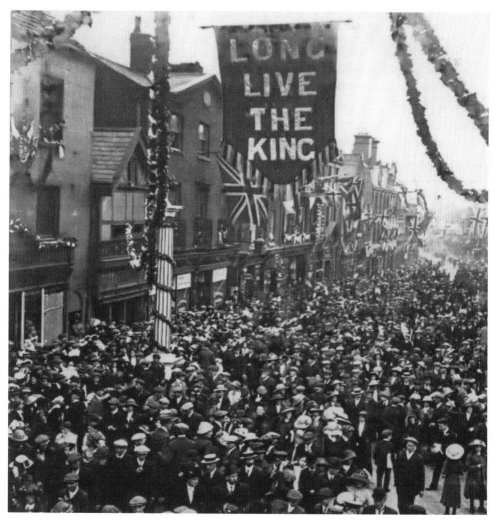

How many of the crowd waiting to welcome King George V to Bridge Street in July 1913 would soon be serving their country during the war?

In July 1913 Warrington welcomed King George V and Queen Mary at the beginning of their tour of Lancashire which was at the height of its industrial power. The town was seen as the gateway to the region because of its transport links. Warrington was one of Lancashire's major industrial towns with a population of about 65,000 and many had turned out to view the lavishly decorated streets and welcome the royal visitors in a show of spontaneous patriotism. In 1913 two major projects were taking place in the town centre with the redevelopment of properties at the junction of Bridge Street and Buttermarket Street and the construction of a new Warrington Bridge which was also important for the regional transport network.

In a striking parallel a century later as Warrington prepared to commemorate the centenary of the outbreak of the First World War in the autumn of 2014 final plans for the redevelopment of Bridge Street and proposals for a new Mersey crossing at Warrington were announced. However, modern day Warrington has changed almost beyond recognition as the town has since become part of Cheshire, with a

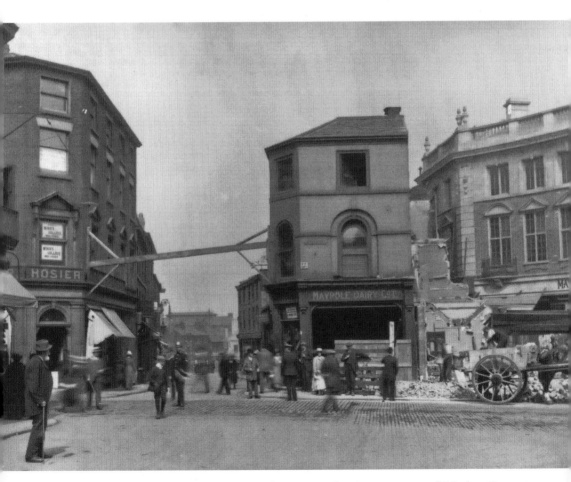

The rebuilding of the Bridge Street and Buttermarket Street corner of Market Gate nears completion.

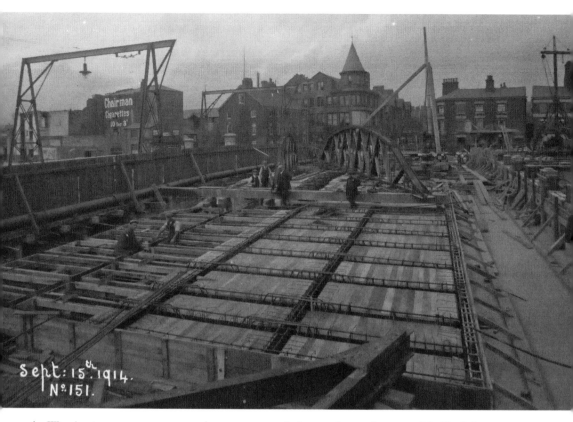

Sept: 15th 1914.
Nº 151.

As Warrington went to war good progress was being made on the second half of the new Warrington Bridge.

population that has almost trebled in size and without the heavy industry and many of the accompanying social problems which characterised Warrington in the years immediately prior to the outbreak of the First World War.

A detailed portrait of Warrington in 1913 emerges from a comparative study of *Livelihood and Poverty in Northampton, Warrington, Stanley and Reading*, conducted by A.L Bowley and A.R. Burnett-Hurst who noted that the town possessed,

A diversity of industry which is seldom to be found in so limited an area ... There are in Warrington some of the largest ironworks in the United Kingdom. There are also several wireworks, where the processes of wire drawing and wire weaving are carried out. Firms manufacturing bedsteads, tubes, boilers and engines and two of the largest gas–stove works in the country ... A well-known firm of soap manufacturers (Crosfields) employs a large number of persons. In addition there are tanneries, a cotton mill, fustian-cutting factories and breweries. Other important trades are those in boxes, printing, glass, rubber, flour, white-lead, timber and building materials. With so many industries ... the town escapes comparatively lightly when one or a few of its trades are suffering from commercial depression or the effects of a strike.

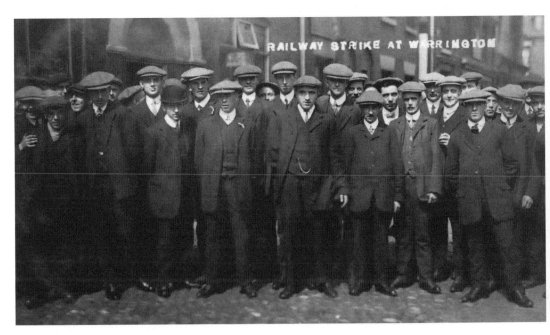

RAILWAY STRIKE AT WARRINGTON

Warrington workers take part in the National Railway Strike of August 1911.

Despite this Warrington had not emerged unscathed from the industrial unrest of 1911–13 which saw trade unions and employers locked in conflict across Europe with 200,000 on strike in Britain alone. As a major industrial centre, Warrington had experienced its share of the national unrest and by early August the town was still feeling the effects of a strike in the tanneries. The town's railway workers took part in the National Railway Strike of 18–19 August 1911 to demand an increase in pay of 2s a week and a fifty-four hour week instead of sixty hours. A national state of emergency was declared and at Warrington three hundred and thirty six men and fifteen officers of the 18th Hussars were sent to guard railway property and ensure the movement of essential supplies.

The suffragette movement was also agitating for votes for women and, although their tactics were proving counter-productive, many local women, like the Broadbent sisters of Latchford, had their opinions on the events of the day. Traditionally supporters of the Liberal party, the Broadbents began to move towards Conservatism to combat the rise of the organised labour movement. Sylvia Broadbent's diaries chronicled the events leading up to the outbreak of war and for her the rights of the workers were less important than a perceived threat to the stability of the country and an attack on the establishment. In August 1911 she complained that the country had:

> Embarked on an industrial Civil War. The Seamen's strike was followed by the Dock Labourers, Carters and finally a General Railway strike. All trade was stopped or terribly disorganised. The hooligan mob in London and Liverpool and most of the large towns added enormously to the difficulties of the police and so serious was the rioting that an Army Corps was called in with great promptitude.

The Broadbent sisters of Latchford. Left to right: Sylvia, Margaret, Lucy and Constance.

On 24 February 1912, miners began a strike which would last for 24 weeks with devastating effects for many Warrington industries. The town's iron and steel works were especially hard hit because, without coal, the furnaces were shut down, with 1,300 being laid off at Pearson & Knowles works alone. There were no state welfare benefits for the workers and families came close to starvation.

Living conditions were usually harsh for many Warrington families, as Bowley and Burnett-Hurst noted:

> In the older and central portion of the town comprising chiefly Town Hall, Howley and St John's Wards are narrow streets and back courts and alleys containing insanitary dwellings, now gradually disappearing partly through street widening, partly through the work of the Health Committee. Shops and offices are largely supplanting residences in the middle of the town … but the stranger is struck by the appalling condition of some of the houses comprising the courts off Winwick Road, also the dwellings in the neighbourhood of Brick Street.

Here would be found many of the workers in Warrington's factories although new streets of terraced housing were also emerging, but without the plumbing, electricity and the household appliances which twenty-first century homeowners take for granted.

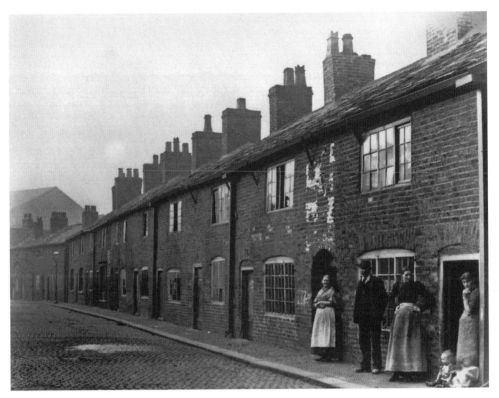

Working class housing off Winwick Road.

While many Warringtonians were preoccupied with the struggles of daily life others were concerned with international events and especially the German Emperor (or Kaiser) Wilhelm II's growing preoccupation with rivalling the might of the British Empire. They watched with unease the expansion of the German army and navy and worried that Britain's armed forces were inadequate and that lessons had not been learnt from weaknesses exposed during Britain's involvement in the Boer War of 1899-1902. Sylvia Broadbent feared that war was looming in her diary entry for October 1911:

> France and Germany having conflicting interests in Morocco, we were very nearly forced into war as the ally of France, but Britain taking a firm stance was the means of preventing Germany attacking France and for the time being a settlement was made ... but later we heard what a very near thing it had been to war. This is surely an additional argument for National Service.

Many Warrington men had served in the Boer War as members of the South Lancashire Regiment Volunteers. Among them was Captain George R. Crosfield, a director of the local soap making firm of Joseph Crosfield and Sons. He became a leading member of The National Service League, whose president was Lord Derby of Knowsley.

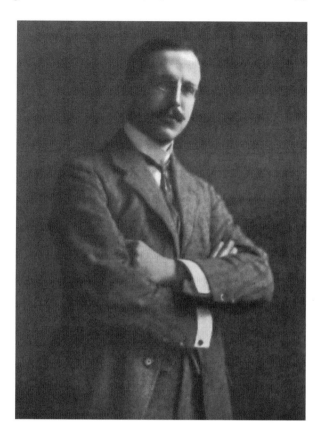

Capt. G. R. Crosfield.

The movement aimed to introduce compulsory military training for all able bodied males to match the threat from Germany and also saw this as an antidote to teenage delinquency and trade union unrest by bringing discipline to the workers. The National Service League actually had little national support and was opposed by Liberals who disliked the concept of compulsory service while even some Conservatives thought that conscription was un-British. Under Crosfield's leadership, however, Warrington became a stronghold of the movement and his views were also supported by Sylvia Broadbent who spoke at a National Service League meeting at Latchford in February 1910, declaring that, 'The army was very small compared to the extent of territory it needed to protect and between October 1905 and January 1909 had been reduced by over 20,000 men.' Another speaker, Major Logan said that,

> as far as training and physique went, the English soldier was quite the match of any Continental soldier, but it was absurd to pretend that men who had only a few days training a year could compete with men who were taken away from their civil employment and devoted two years at least entirely to learn how to fight.

Meanwhile The Church Lads Brigade was also preparing the country's youth to do their patriotic duty. The organisation had been founded in an effort to bring the values

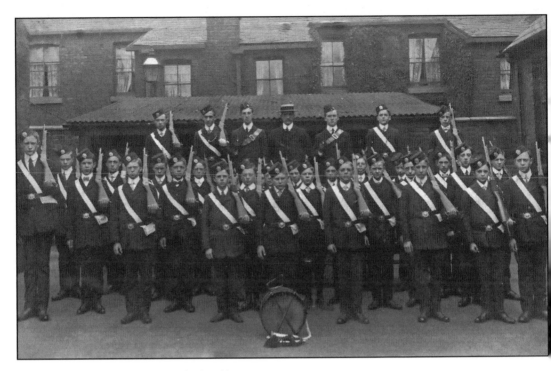

St Paul's Church Lads Brigade shoulders arms.

of loyalty, self-sacrifice, patriotism and team spirit learnt at public schools to children from poorer families … and ideally bring discipline to slum children. In reality the aim to turn the children of the slums into worthy servants of the empire was less successful than attracting the sons of more respectable working class families. The movement's unique offer was to combine the heroic ideals of Christianity with the concept of 'manliness'. The Brigade attracted young boys by combining bible study with military drill and team games like football. In Warrington the organisation's main advocate was the Reverend William Bracecamp, the Rector of St Paul's Church in Bewsey Road who was also closely linked with the South Lancashire Regiment.

However, despite the fact that some leading Warringtonians had seen the storm clouds gathering in Europe the events of August 1914 seemed to catch many of the population by surprise and the last year before the conflict would seem a golden era in retrospect as Sylvia Broadbent recorded in a post war entry, 'In 1933 I cannot refrain from dwelling on that very happy year (1913) the last before the First World War which broke down and changed so much of the happy past.'

CHAPTER 2

WARRINGTON GOES TO WAR

Who that lived in Warrington in the first week of August 1914 will ever forget the stirring and dramatic events of that fateful time when war came suddenly like a bolt from the blue?

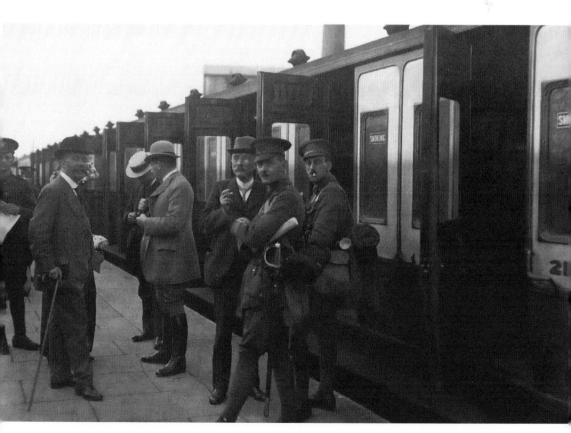

Warrington Territorials leave for camp on 3 August, seen off by Peter Peacock the Mayor of Warrington (second from left); Sir Gilbert Greenall, (fourth from left) and Arthur Bennett (third from right).

The August Bank holiday fell at the beginning of the month in 1914 and the town's main preoccupation was the weather while the town's reserve soldiers in the South Lancashire Regiment had just set off for their annual training camp. When the news that the country was at war was announced on 5 August it is doubtful that many Warringtonians could explain why the assassination of the Arch Duke Franz Ferdinand in Sarajevo or how Britain's alliances with France and Russia had led Britain into war. The local press had given scant coverage to the assassination of the Archduke Franz Ferdinand by Gavrilo Princip, a member of a terrorist group known as the Black Hand Gang, on 28 June 1914 while the Arch Duke was on an official visit to Sarajevo in Serbia. Franz Ferdinand was the heir to the throne of the Austro Hungarian Empire so Austria declared war on Serbia.

All the main countries in Europe began to take sides with Austria or Serbia leading to the First World War and the average man or woman on Warrington's streets would have found it hard to know who were Britain's friends and enemies in the war at first. Eventually they would come to identify the two opposing power blocks of the Allies made up of Britain, France and Russia (and later the USA) and the enemy powers of Germany, Austria and Turkey.

If this lack of understanding of worldwide events seems surprising today life in August 1914 was very different. It was a time without radio, television, the Internet or social media. As Britain prepared to remember the centenary of the outbreak of the First World War in August 2014, the serious newspapers and the 24/7 satellite news channels carried stories of the dangers of Russia's involvement in Ukraine and how events in Gaza, Syria and Iran and the threat to the West posed by the militant fighters of Islamic State might lead to another world war. Despite this easily accessible media coverage, it is doubtful how much ordinary Warringtonians in 2014 knew or cared about these international events as they went about their daily lives.

On 5 August 1914 the initial reaction in Warrington was short-lived panic buying in the local shops as the local press reported remarkable scenes that afternoon in some of the Warrington shops.

> The war fever was then at its height and the womenfolk were anxious to lay in a full cupboard of supplies. They crowded into town and the principal shops that deal in food stuffs became so crowded that in some cases they had to close earlier than usual … The bakers, grocers and butchers seem to have felt the effect most.

In August 1914 most local people relied on their local newspapers to give them a summary of recent national events and more detailed coverage of local affairs. Warringtonians understood that the *Warrington Examiner* reported events with a Liberal Party bias while the *Warrington Guardian* presented a Conservative Party viewpoint, under the ownership of Sir Gilbert Greenall and influenced by his even more avidly Tory wife, Lady Frances Greenall. As the war progressed all newspapers were subject to government censorship in case they gave useful information to enemy spies or made people despair that Britain's war was going badly. In August 1914 both papers told their readers in no uncertain terms that the German Emperor, Kaiser Wilhelm II was to blame for the conflict. Readers were told that, when his army invaded Belgium

The *Warrington Guardian's* reporters prepare to file a story of the First World War.

as part of his general's plans to march on Paris and defeat France, Britain was obliged to send her troops to honour a promise to defend Belgium.

On 5 August the *Warrington Examiner* announced starkly, 'There is momentous news today. England has declared war on Germany. Now that the die is cast there must be no hanging back.' In a follow-up article three days later, entitled, 'For Liberty and Honour' the editorial was even more direct;

A week ago there were many who thought that a position of neutrality in the European War would best accord with our interests and the ultimate good of humanity. Today there is not a man or woman in the whole Empire but will vehemently declare for war to the bitter end against that man of blood, the German Emperor.

The *Warrington Guardian* was equally firm in its belief that it was German aggression rather than events in Sarajevo which had led Britain to war in support of a just cause. Its editorial, headed 'The Duty of the Nation' of 8 August asserted that,

> Less than a week ago the hope was general that Great Britain would not get drawn into the European War. That hope has been dashed to the ground. Our worst fears have been realised. We are engaged in a great conflagration destined to stand out pre-eminently as one of the greatest – if not the greatest – in history. We enter the conflict reluctantly, but with a deep and solemn conviction of the righteousness of our cause. The quarrel is not of our seeking. Sir Edward Grey has practised all the art of diplomacy in order to avert the calamity of war. And he has failed, failed because German arrogance demanded from us what we cannot grant.
>
> Our duty is as clear as daylight. It is to give that protection to Belgium which she has sought; to extend to our neighbours and friends across the Channel that assistance she has a right to expect. We enter into the struggle believing sincerely that God will defend the right.

So Warringtonians found that they were part of an international struggle which they would call the 'Great War' rather than the First World War, for they had no way of knowing that

SS *Dryade* at Walton Locks.

there would one day be a second conflict on this scale. Convinced of the justification for war Warrington's first taste of action was at the somewhat unlikely setting of the Walton lay-by on the Manchester Ship Canal. The *Warrington Guardian* reported that,

> At about seven o'clock on Wednesday morning. The German cargo vessel, *Dryade* of Hamburg, had brought a consignment of timber for Messrs R. Naylor Ltd and unloading had already begun. Following the declaration of war, customs officials, assisted by members of the Warrington police force, took possession of the vessel which has since been detained. A search was made for firearms or any other dangerous cargo but nothing of the kind was found. The crew included fourteen Germans, who having signed certain declarations, were told that they would not be allowed to leave the vessel. They calmly accepted the inevitable and have since been kept under surveillance by police officers.

After this decisive action against the enemy the authorities were at a loss over how to deal with their prisoners. Eventually it was decided to admit the German captives to Warrington Workhouse since they had no means of supporting themselves. However, there were soon complaints from local rate payers who objected to being responsible for their enemies' upkeep.

However, writing in the *Labour Gazette*, Charles Dukes urged against seeing all Germans as the enemy, especially the ordinary workers, who were at the mercy of the government. Dukes had moved to Warrington in 1893 at the age of thirteen and soon started work as a labourer in one of the local iron works. By 1911 he had become a full time secretary of the local branch of the Gas Worker's Union, increasing its membership tenfold by the outbreak of the war. He was also active in politics; in 1899 he joined the Independent Labour party and by 1912 he had moved further left to become a member of the board of the national executive of the newly formed British Socialist Party.

In the *Labour Gazette* of August 1914 he declared that,

> Like a bolt from the blue, War has fallen upon Europe ... To say that the Kaiser is mad does not assist in the least in an understanding of the problem. If it were so, the obvious would be to remove the Kaiser; but we are fighting Germany which in all probability contains a majority of Republicans and Socialists who do not want war ... That the Kaiser and the educated gorillas who have planned the disruption of Europe by piling up munitions of war should be repulsed and defeated no sane mind can doubt for a moment. But when that is done, what then? Who is to gain? I would have Germany defeated for the sake of the German people, but the German nation must not be despoiled in the operation. As a civilized nation upon which European advancement is largely dependent, she must be allowed to continue her progress.
>
> Whatever may be thought of British intervention, one thing is certain, England could not stand aside whilst the balance was moved in the interest of any of the powers ... we could no more allow German aggression to go unchallenged than we can encourage Russian expansion when peace is again restored ... It is unsafe to prophecy the end, but unless something in the nature of a miracle happens,

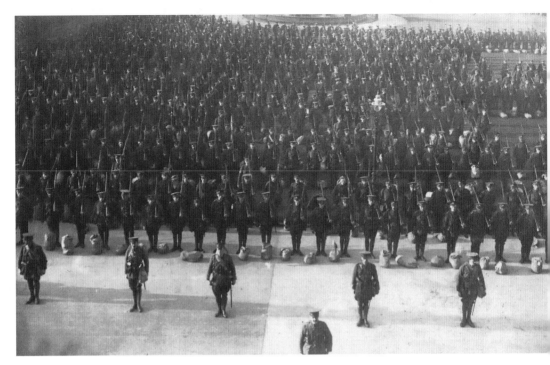

The Warrington Territorials assemble on the Town Hall lawn. © Lancashire Infantry Museum

Germany will be faced not only with War on her frontiers but also Revolution. Social democracy is sure to take advantage of the inevitable reaction of defeat. The Republic of Germany may be the result. Let us strain every effort to put down her military adventurers, but by no means set back her social progress.

Duke's views were not entirely shared by the majority of his Labour colleagues and he became an increasingly divisive, but vocal, figure in local politics as the conflict progressed. In early August 1914, the majority of local people were swept away by patriotic support for the war – at least if contemporary press reports are to be believed.

First to see military action were the Warrington men who formed part of the Prince of Wales Volunteers (PWVs) attached to the South Lancashire Regiment. The British Army had been reorganised in 1907 leaving a small regular army to fight abroad and reserve forces of the Territorial Army, volunteers like the Prince of Wales Volunteers (PWVs), whose role was home defence but, with their agreement, they could be called on to fight oversees. In August the British Expeditionary Force (BEF) was to be sent to France to bolster the French army, but also to protect the Channel ports against a potential German invasion of Britain.

In August 1914 the existing PWVs volunteered to serve with the BEF following a swift return from their annual camp when war was declared. According to local press reports of the day, at a meeting in the Parr Hall addressed by Captain Crosfield, they unanimously agreed to serve abroad, 'all hands shot up like so many rifles

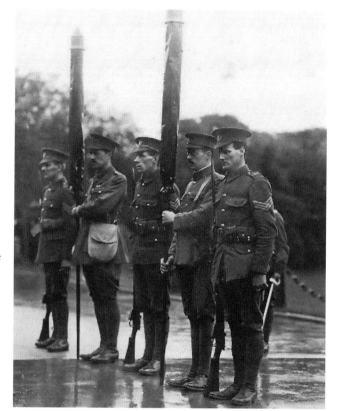

Right: The colours of the 4th Battalion Prince of Wales Volunteers, South Lancashire regiment, were delivered to the Deputy Mayor (Cllr Joseph) during the absence of the regiment from the borough. © Lancashire Infantry Museum

Below: Captain Layton gives last minute orders to his men. © Lancashire Infantry Museum

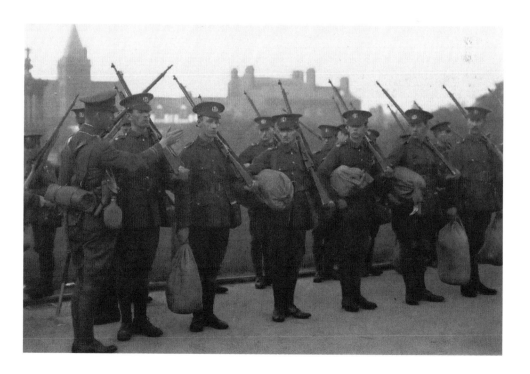

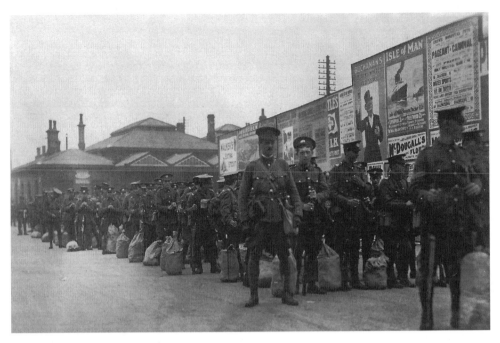

The 4th Battalion assemble at Bank Quay Station. © Lancashire Infantry Museum

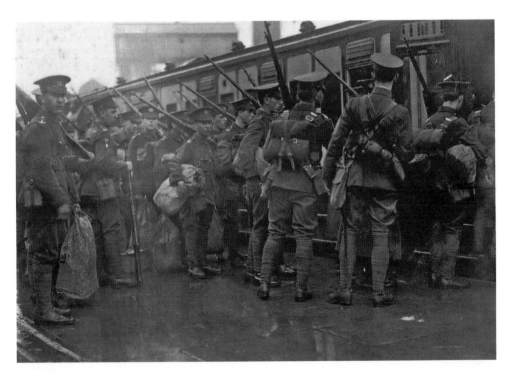

A last look back at Warrington as the troops leave Bank Quay for France. © Lancashire Infantry Museum

being shouldered. The men were enthusiastic and applauded the name of the King and Dear Old England'. The men swiftly went home to pack and then returned to assemble on the Town Hall lawn before marching off to Bank Quay station to start their journey to France.

With so many bread winners doing their patriotic duty by serving in the armed forces, the authorities realised that the families they had left behind would soon starve as working class families unfortunately had no savings to rely on in times of hardship and this was long before the creation of the welfare state. Several firms arranged emergency payments and perhaps not surprisingly, given Captain Crosfield's military connections, Joseph Crosfield & Sons led the way. They guaranteed to hold open the jobs of all their men who were called on to serve in the army, navy, territorial force or as ambulance men for the duration of the war while the time they spent on active service would be counted as part of their entitlement to long service pay and holidays. In addition the wife of every serving man would receive half of his wages and an additional payment for every child younger than fourteen years of age.

Warrington Territorials serving with the South Lancashire Regiment soon found themselves in the thick of the action on the battlefields of France and Belgium.

NOTICE.

Special Allowance to the Wives of Workmen called out to the War.

The above will be paid on Thursday each week, at 5 p.m., as follows :---

FORGES & MILLS - At Piece Wages Office, Bewsey

ENGINEERING (Including Mr. Holt's Men) - At Day Wages Office, Smiths' Works

Those entitled to receive the allowance should attend the Offices as above, BEFORE Thursday next, to give particulars relating to their claims.

The Pearson & Knowles Coal & Iron Co. Ltd.

Dallam and Bewsey Forges,
10th August, 1914.

Emergency allowances for soldiers' dependents.

Sgt. Greeley of the 2nd Battalion South Lancashire Regiment recounted his experiences after the early battles at Mons for the *Warrington Guardian* in early October 1914.

> I have been very lucky as I have been under shell fire ever since I got here … It is terrible the sights we see. We have been walking over German dead bodies for days. We often get wet to the skin. We have no overcoats now. We lost them in the Battle of Mons. We were unable to carry them, so we had to leave them in the trenches. At night time we have to lie down in the rain … that is when we do lie down which is not often. It makes our blood run cold to see men, women and dear little children running for their lives out of the villages and leaving their homes. The places have been set on fire by German shells. The war does not seem like finishing yet awhile, judging from the war news. It is always 'heavy German losses,' but they never seem to be getting any smaller. As they get knocked down there seem to be dozens to come in each man's place. But they must be getting fewer somewhere. They keep coming hundreds at a time to give themselves up as prisoners.

As the war progressed, Sgt. Greeley's rather pessimistic view of the fighting might have been subject to more rigorous censorship but in these early days it served as a useful tool to recruit many more local volunteers. However, it was also an early hint that this war was unlikely to be over by Christmas.

CHAPTER 3

YOUR COUNTRY NEEDS YOU!

According to the local press, the call 'Your King and Country needs you' evoked an immediate and magnificent response from the young manhood of Warrington in every walk of life. Of course this could also have been a means to encourage yet more to volunteer to join General Kitchener's army although it is doubtful that the famous war time poster of Kitchener was ever widely seen on Warrington streets. They would, however, have been familiar with his name since Field Marshall Lord Herbert Horatio Kitchener was already a war hero by 1914 and the ideal figure to lead a national call for a volunteer army.

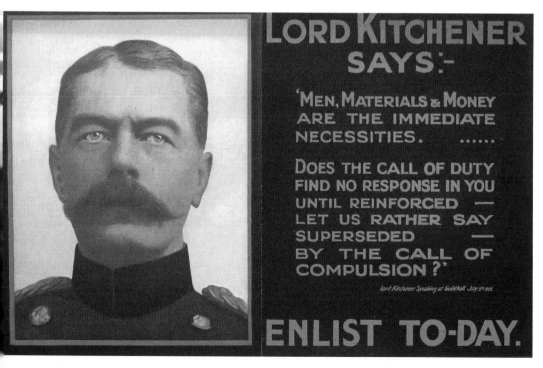

The official Kitchener recruiting poster rather than the rarely seen iconic image of his pointing finger.

In early 1914 the British regular army had around 11,000 men less than that specified in the 1907 army reforms and Kitchener believed that an army of volunteers who believed in the cause for which they were fighting would fill this gap. Working class volunteers would have been ideal for Kitchener's plans as they were considered deferential to their employers and perceived to expect little from life and indeed many workers in Warrington were encouraged to join by employers such as Crosfields or Rylands. Many men from the same workplace joined the 4th Battalion of the South Lancashire Regiment which became an unofficial 'pals battalion' where they would train, serve and (in the most tragic circumstances) later die together.

In the autumn of 1913 *Bowley and Burnett-Hurst* had noted that conditions in the iron trade were normally hard for the workers with the work 'heavy and arduous ... irregularity of meal hours ... and the men exposed to great variations of temperatures,' and, because of their irregular shift patterns, it was difficult for them to attend night school to better themselves. Men used to such harsh working conditions might well find it relatively easier to adapt to conditions in the trenches of the Western Front than the more privileged middle class professionals or the officer class. Working class recruits knew their place in life and tended to react to the officers with the same obedience they gave to their workplace foreman or manager. However, local readers of the *Labour Gazette* of October 1914 were asked to consider what exactly the working man should expect to gain in return for serving his country.

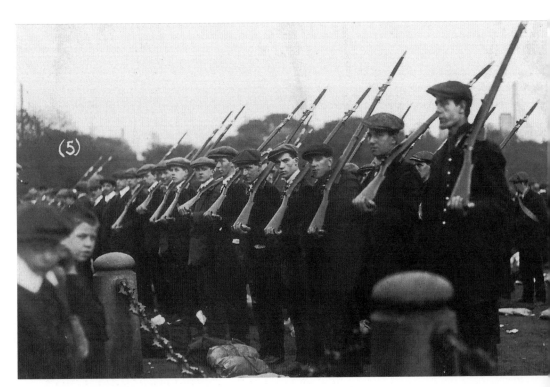

(5)

Raw recruits drill at the Town Hall in temporary uniforms.

What is he going to fight for? Being possessed of at least ordinary intelligence, he expects something more tangible than the thanks of a grateful country. We have too many one-armed and one-legged patriots left over from the last war, selling matches in the gutter to remind us what form the country's gratitude is likely to take. The question which concerns the working man … is what guarantee has he that his dependents will be properly cared for while he is away?

The rich have secure homes and incomes, the average working man lives at best a hand to mouth existence, with nothing more than a week's wages between him and the workhouse. The rich have interests vested in the country: the working man possesses nothing but what he could carry away without undue inconvenience. The rich are fighting to preserve a condition of things which guarantees them a life of ease and opulence, the working man is fighting to preserve a condition of things which denies him even social recognition of his right to work. … When a worker who owns nothing volunteers for active service … and hundreds and thousands of them have already done so … he must perforce sacrifice fifty percent of his wages. Where is the justice in this?

However, these sentiments were unlikely to have deterred the initial flood of volunteers. The first rush of recruits were often the young and the unemployed as older workers

In September 1914 the town gave a rousing send off to two groups of 500 men who were members of the new battalion to be known as the 8th Service Battalion South Lancashire Regiment.

had family commitments, skilled workers had more job security and farm labourers were busy with harvesting and preparing for next year's crops. The younger men saw the army as an opportunity for better wages than awaited them in local workplaces and also a chance to see the world outside the town while doing their patriotic duty.

By early autumn of 1914 the town's recruiting offices were swamped. In early September the *Warrington Examiner* had reported that Loyal Warrington was already providing a rich harvest of volunteers.

> Trains packed with loyalists who have joined Kitchener's army at local depots have left the town almost nightly and crowds – in some cases reaching extreme proportions – have gathered outside the entrance to Bank Quay station to give them a send off. The recruits are jolly fellows. They sing, 'It's a Long Way to Tipperary' and other popular songs with gusto. The large numbers of able bodied men who have come forward is very remarkable and so great has been the pressure upon the recruiting officers and medical examiners that undoubtedly they will feel somewhat relieved when the supply is exhausted.
>
> In the town's main streets one cannot move without coming into contact with a merry party whose talk indicates that they would like to be transferred to the seat of the war to have a 'pop' at the villainous murderers of helpless men, women and children. Well done Warrington: loyalty has made your men happy.

Undoubtedly many of the young men, eager to fight, lied about their true age to the recruiting officers and many would-be recruits would have failed a strict medical examination, a fact which could be attributed to their poor living conditions. Bowley and Burnett-Hurst's survey of 1913 had described the town as 'at times one mass of smoke from its factory chimneys which blackens the skies and pollutes the air.'. Added to this was the effect of the noxious chemicals many in the wire and iron trades experienced on the shop floor which did little to improve their health. Army life would probably improve the lot of many of the town's working men who passed their medical as a result of a more wholesome diet, better clothing (and especially boots) and regular medical and dental checks. Although the army needed as many men as possible to pass their medical, men with bad teeth often failed because their rotten teeth could not bite the very hard biscuits in the soldiers' rations and they would starve.

Because the Army found it hard to process the initial rush of recruits in late August and early September the minimum height requirement for volunteers of 5 foot 3 inches was raised for a time to 5 foot 6 inches. As volunteer numbers fell in the coming months the minimum height requirement was lowered again and, as *The Times* newspaper pointed out, a short soldier was useful for the campaigns because, 'besides lessening the size of the target for the enemy to hit, he requires shallower trenches'.

Once the initial popular enthusiasm for the war had died down it was essential for the government to maintain a steady flow of recruits. A national poster campaign was launched and copies were sent to Warrington's Library and public buildings for

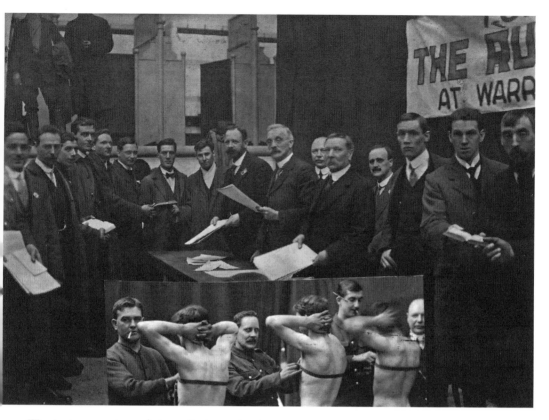

Warrington recruits at their medical examination.

display. Brightly coloured posters with striking images and memorable slogans were the ideal means of mass communication in an age before television, the internet and social media. Posters were used as propaganda tools by the government because they were cheap to produce. Advertising posters were already successfully used by businesses to sell all kinds of products to the public. Poster campaigns could reach all classes of people in the largest city and the smallest town. The government needed to influence public opinion by persuading people to accept selected official information – otherwise known as propaganda. The Parliamentary Recruiting Committee was responsible for the publicity campaign and produced 12,435,500 posters of various sizes and in 164 designs. Most posters were issued in the first year of the war to recruit volunteer soldiers.

The artists and caption writers used a variety of techniques to persuade men to volunteer. By appealing to patriotism and mentioning a sense of duty or comradeship (e.g. 'We're All In This Together,') the posters sought to imply that the war would be an adventure, a chance to see the world. Artists also used emotional blackmail, asking questions of observers such as 'What would your wife or child think of you if you don't volunteer?' and 'All your friends have joined up; why haven't you?' The posters used examples of the enemy's evil actions (real or fictional) claiming the enemy has killed

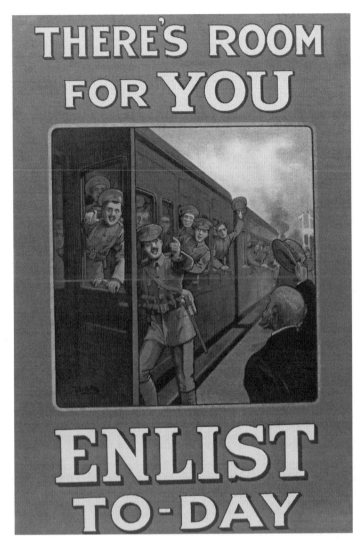

'There's Room for You'
by W. A. Fry, 1915.

innocent women and children, prompting onlookers to remember what had happened in Belgium or, later, what happened to the Lusitania.

By mid-1915 news of the reality of life on the Front Line was widely known back home. The public had begun to reject this recruitment propaganda and tens of thousands of posters lay unused in storage. Later campaigns focused instead on the war on the Home Front and the need for women to take on men's jobs to keep vital services running or ensuring people did not waste food and recycled to save scarce resources for the fighting forces.

Warrington politicians also played their part in the recruiting drive by holding public meetings which were designed to whip up mass enthusiasm and persuade groups of friends in the audience to enlist together. Leading Conservative politician Robert Pierpoint's speech to a public meeting in early October 1914 was reported in

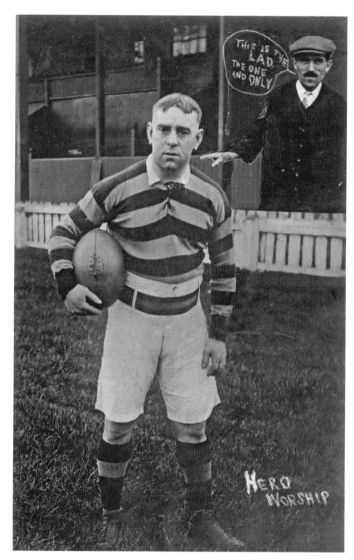

Warrington's rugby league club saw seventy four of its players in action on the battlefield by 1917. Among them was the popular figure of Jack Fish who enlisted in the King's Royal Rifle Brigade. Many of his fans followed his example and the brigade was nicknamed Fish's regiment.

the *Warrington Examiner*, which had shelved its normal Liberal bias during the war. His message was addressed to any young man who might be thinking,

Why should I forsake my work? Why should I be uncomfortable when others will do the job? How will they react in peace time when their children ask what they did in the war? What if they answer I did nothing in the Great War because it was too difficult and too dangerous. On the other hand think of the pride of the man who was able to say, I served with the South Lancashires. Surely you must hear the trumpets sounding, you must hear the drums beating? Listen while they call. Don't let your doubts influence you, but go forward like men who serve the King, the kingdom and the Empire.

Anti-German lapel badge.

Pierpoint's speech served as a rejection of an article printed in the *Daily Herald* in July urging workers:

> Don't be a soldier … Be a Man. Young man – the lowest aim in your life is to be a good soldier. The good soldier never tries to distinguish right from wrong. He never thinks, he never reasons; he only obeys. A good soldier is a blind, heartless, soulless, murderous machine. He is not a man. He is not even a brute, for brutes only kill in self-defence. All that is human in him, all that is divine in him, all that constitutes a man, was sworn away when he took the enlistment oath. His mind, his conscience, and his very soul are in the keeping of his officer.

Warrington's press concentrated on using anti-German propaganda to galvanise men to volunteer and train to go into action. Anything with a German name was very unpopular in Allied countries as the war progressed. The British Royal family changed their name from Saxe-Coburg to Windsor. German shepherd dogs were renamed Alsatians. The Americans wouldn't eat hamburgers, so they were called 'liberty sandwiches' instead.

The *Warrington Examiner* did, however, carry the report of Germans and British fraternising during the unofficial Christmas truce of 1914.

> Writing on Boxing Day from the trenches to his wife a Lancashire soldier gives the following account of the exchange of Christmas greetings and hospitality between our troops and those of the enemy. The Germans had a lot of Christmas trees lit up with candles and our men wrote on a board, *A Merry Christmas*, and the Germans wrote on another, *Extreme Thanks*. Then they beckoned for one of our men to go for cigars and he met the Germans half way between the trenches. This was the Welsh

fusiliers. Then their officer brought a bottle of champagne which was drunk between them. Then all the men came and shook hands. The Germans having occupied a brewery rolled two barrels of beer up to our men. There was a stoppage of the war for 24 hours but they are at it again this morning. The Germans were thankful for the jam etc which our men gave them. They say their officers fire on them if they don't fire on us every time they see an English soldier.

However, the authorities swiftly realised that showing the Germans as ordinary human beings was counter-productive and as local families learnt the reality of life on the battlefield from letters home from their loved ones serving on the war front more direct anti-German propaganda was needed. The *Warrington Guardian* gave a detailed report of Father Whittle's sermon at St Alban's Church in January 1915 which stressed the war was a religious crusade with Britain on the side of right.

We are fighting for Christ against anti-Christ. I don't say the Kaiser is the anti Christ … but he is fighting against God. We are fighting for God and Christ against the Devil and anti Christ … We are fighting for national liberty for each country whether large or small, for the right to live and not to be interfered with. We are fighting against oppression and tyranny, for a plighted troth against broken treaties, and what are called scraps of paper. Germany promised to preserve the integrity of Belgium but we know what has been done. We are fighting for what is right and just, against might and what is unjust. Germany a mighty power, had been prepared for this war for forty years, and it is a terrible thing to break her might but let us hope it is being broken. We are also fighting for peace. We want no war and we want no territory, except that we already possess, but this man, the Kaiser, would have the whole world for his territory … We are fighting for peace against war or the continued danger of war. We must conquer. The world is ruined unless we do so.

Accounts of German atrocities were also widely quoted in the local press soon after the outbreak of the war, although many were probably based on rumours. These stories usually featured attacks on young children and defenceless women or civilians being used as human shields by German troops. Some of these stories probably had a bearing in truth during the German invasion of Belgium but exaggerated horror stories made good copy and good propaganda.

In early April 1915 the *Warrington Guardian* reported on Captain Townroe's Easter Bank Holiday recruiting campaign at local cinemas for 600 volunteers to form the new Third 4th Battalion of the South Lancashire Regiment. He appealed to all young men in the audience who were over nineteen years of age, not less than 5 foot 1 inches height and physically fit, to ask themselves whether they were prepared to make a great sacrifice and respond to Lord Kitchener's appeal. After eight months of fighting Germany was still fighting, for the most part, outside her own land and the terrible casualty lists showed why more men were essential in this fight for our existence. He believed the appeal would not be made in vain to the young men of Warrington to come forward to prevent Warrington women and children suffering what the Belgian women and children endured.

Townroe used accounts of German atrocities to appeal for volunteers.

It was hard to realise what war meant but he would give one example which he had heard from an officer of the South Lancashire Regiment. The officer was going along a road in Belgium when he noticed what he thought was a curious knocker on a door. On making a closer examination he was horrified to find it was the body of a baby which had been nailed alive to a door ... We must have faith in Lord Kitchener and when he gave orders that another Warrington battalion was needed, surely the eligible young men, who could be seen in the town in great numbers would come forward. Come to the Drill Hall any evening. We will give you a warm welcome; if passed by the doctor, you will be sent straight to Tunbridge Wells and you will be loyally taking your part in defeating German militarism utterly.

However, one major flaw in Kitchener's recruiting drive soon became obvious as the army realised there was no adequate infrastructure to deal with the rapid numbers of volunteers. There were not enough uniforms, not enough barrack accommodation and not enough kitchens to feed them all. Many recruits found themselves in temporary navy uniforms donated by postmen, drilling with dummy rifles and living in tented villages despite the cold weather.

Despite the need for fighting men overseas several months of training were deemed necessary to turn the raw recruits into soldiers. They needed to be toughened up; learn military discipline and practice trench warfare before marching off to the south coast to embark for action. The South Lancashire Regiment put raw recruits through their basic

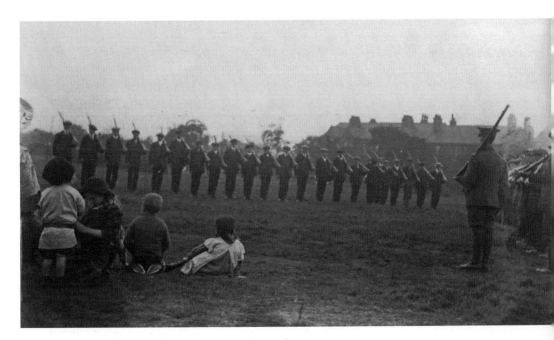

New recruits' basic drill at Bank Park in September 1914.

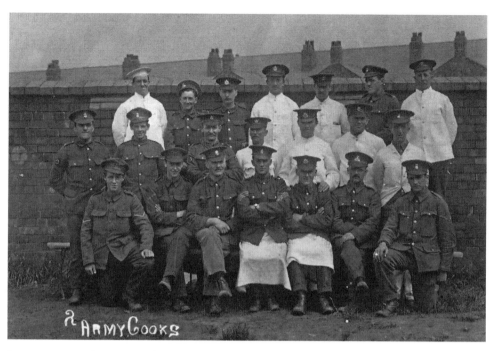

In June 1916 Sydney Upton from Birkenhead (second from the left on the front row) began his training as an army cook at Orford Barracks.

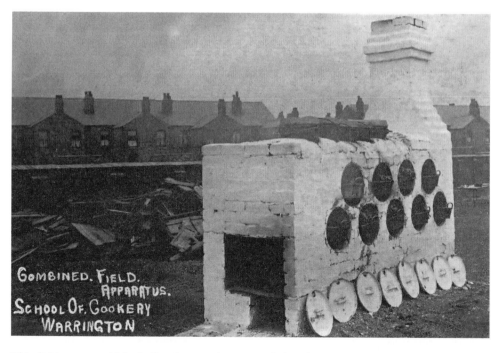

This field oven could be built wherever it was needed and prepared several different types of food at once for between twenty five to fifty men.

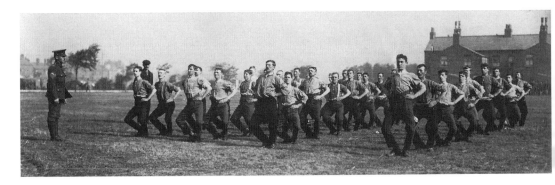

Learning military discipline at Orford Barracks. © Lancashire Infantry Museum

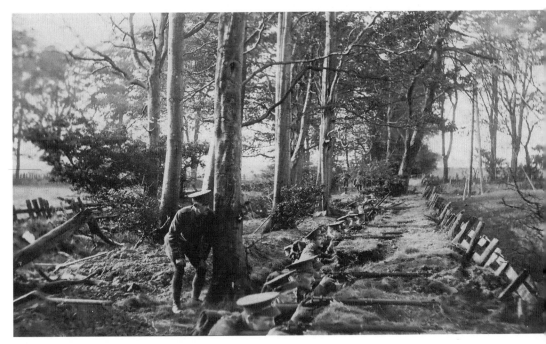

South Lancashire recruits practice trench drill in Scotland. © Lancashire Infantry Museum

training. In September 1914 the *Warrington Guardian* reported that, '300 more for the Territorials have been shouldering their arms and executing drilling movements on the children's recreation ground in Bank Park, which at times very much reminds one of a barracks square ... that is if the eyes fail to observe the green trees and the grass'.

Other recruits were put through their paces at the South Lancashire Regiment's depot at Orford Barracks which also operated a training school for army cooks as the war machine needed a huge support infrastructure as well as front line troops.

The Warrington men who had rushed to join Kitchener's army in the first months of the war were not destined to arrive at the newly established Western Front until

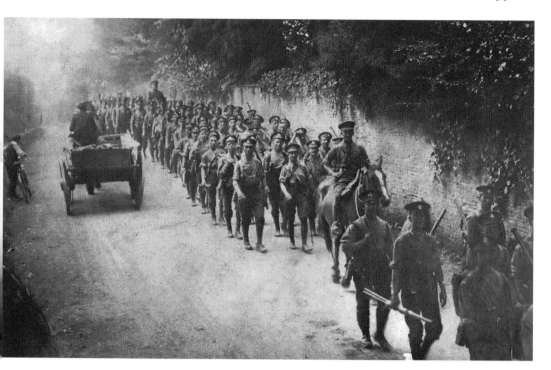

The new recruits arrive 'Somewhere in France'. © Lancashire Infantry Museum

early 1915. Despite months of training nothing could prepare them for the bitter cold and the clinging mud of the hastily dug trenches around Ypres in Belgium.

Now the harsh reality of war in the trenches began to sink in and they longed to be back in dear old 'Blighty'. (This was the soldiers' name for Britain, derived from a Hindi word, *bilati* meaning foreign.) Meanwhile those left behind in Warrington realised they also had a part to play in the war effort on the Home Front.

CHAPTER 4

WARRINGTON'S INDUSTRIES AND THE WAR EFFORT

'The time will come when the men in the firing line will realize that their comrades at home have borne their share of the burden and the heat of the day', claimed the *Warrington Guardian* in 1916. Warrington's industries undoubtedly made a major contribution to the war effort but contemporary details of this war work are sketchy as the *Warrington Guardian* explained, 'On this aspect of the struggle prudence … and the ever-vigilant Censor … forbids us to write except in the vaguest terms.' However, wartime company reports, claims for exemptions at military tribunals together with post war company histories give some clues to the wartime output of Warrington's factories.

The Munitions of War Act of July 1915 enabled Lloyd George to prioritise supplies of power, fuel and transport and take factories under government control to produce munitions and safeguard supplies for the armed forces. As the war progressed the government categorised many more industries as 'munitions,' beyond those supplying shells and bullets, manufacturers who supplied items such as tents, uniforms, boots, army biscuits and jam, sacks and ropes, drugs and bandages found themselves classified as munition works under government control. By 1918 about five million workers nationally were engaged on government contracts.

By the end of January 1916 Crosfield's works was under the control of the Ministry of Munitions allowing them to make the glycerine which was vital to the manufacture of ammunition. On 30 August 1915 John Paul Rylands (of Rylands Wireworks) noted in his diary that, 'The government have taken over the works'. Pearson and Knowles annual report for 1917 stated that the firm had traded until Dec 1915 when it was taken under the control of Ministry of Munitions. The works was extended for supply of iron and steel on the instructions of the Ministry. Warrington's heavy industries such as the iron, steel and especially the wire works were crucial to the supply of armaments; torpedo nets and, above all, barbed wire that was essential for trench warfare. Even smaller works such as Caldwell's Stockton Heath Forge played an important part by producing the spades used for digging the trenches.

Warrington's British Aluminium works also expanded production during the war years when much of the factory's production was sheets of cupro-nickel for rifle bullets. It is believed that a new extrusion press was being shipped to the

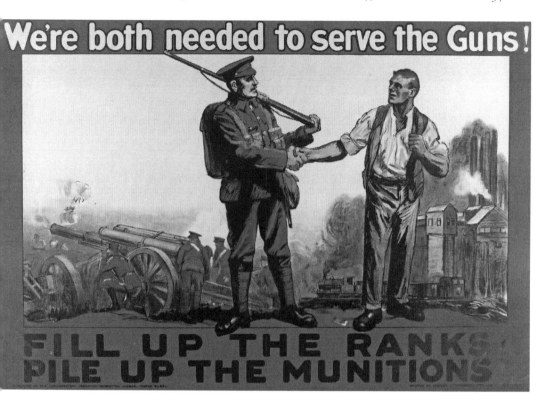

By 1915 munitions workers were as important as soldiers.

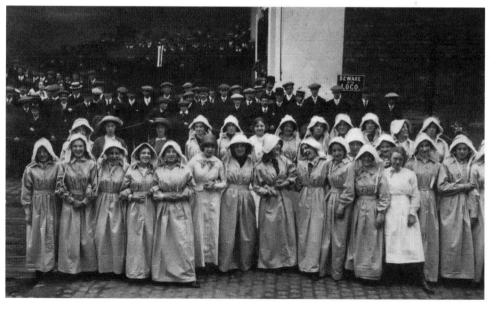

Crosfields' employees who helped create glycerine needed for munitions, which was a by-product of soap making.

Warrington factory from America on the *Lusitania* when it was sunk by a German submarine. By 1917 the majority of the workforce was women who proved equal to the heavy work. While the factory benefitted from the munitions work, by the early 1920s, the aluminium industry would be hard hit by the post war economic depression.

During the war years 90 per cent of the output of Armitage & Rigby's Cockhedge cotton mill was for military usage, ranging from bandages to khaki drill cloth, twill for tenting and ground sheets and three million metres of striped flannelette for the French army (which was probably used to line cotton gas masks.) The mill also wove large quantities of khaki cloth which was dyed with iron rust and which did not fade or shrink. Armitage & Rigby also got an order in April 1918 to weave sturdy cloth to cover aeroplane wings. For the home front, the mill produced coloured cotton blankets which would previously have been imported from Holland and Belgium. By 1918 ninety percent of their looms were engaged in work for the war effort on fixed price contracts but after the war ended the mill suffered from a slump in trade.

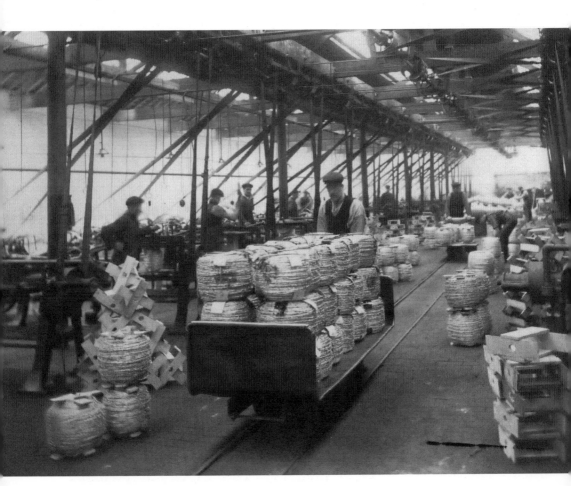

Rylands' workers produce barbed wire for the trenches.

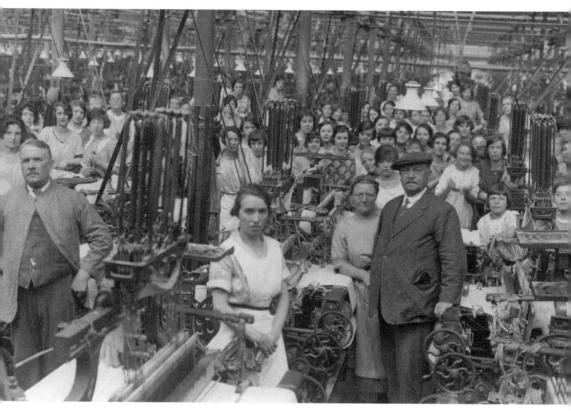

Women weavers at the Cockhedge Mill.

Not all of the town's industries benefitted from the war effort. Greenall's Brewery were eventually compelled to reduce the output of beer by two thirds of what it had been in 1915 because of need to divert grain to food supplies so the greater part of the brewery was empty and disused. The government also wanted to discourage drinking by the workers because they believed it might reduce production in the munitions works. Using the authority of the Defence of the Realm Act, introduced in 1914, they reduced the opening hours of pubs and off-licences and in early 1915 banned the custom of 'treating' or buying a drink for someone else.

The introduction of compulsory military service (or conscription) for all men in 1916 brought new problems for the town. If all the men were called up who would do the heavy or skilled jobs in the factories? Who would keep Warrington's crucial services going? What should happen to those who were opposed to war on grounds of conscience? By the Military Service Act of January 1916 all single men aged 18–41 were conscripted, with exemptions for ministers of religion, the medically unfit, Irish, conscientious objectors and those whose work was deemed essential to the war effort. Workers had to obtain a leaving certificate from their employers before changing jobs and where employers brought cases where men had left their employ without this the tribunals rejected better pay or conditions as acceptable grounds for workers leaving.

In late April 1916 a Second Military Service Act extended conscription to married men. The increased numbers entering military service again led to crisis in supplies of munitions. Badges were issued to munitions workers deemed essential but the government felt too many men had been exempted.

Warrington's trade unions were also divided over the introduction of conscription and the wire drawers decided to put patriotism first by resigning from Warrington Trades and Labour Council which had opposed compulsory military service. The *Warrington Guardian* of 29 January 1916 quoted one of their representative's reasons for their decision.

> We should require every ounce of strength and every man we had got in order to win the war. The Germans acted unfairly in war and in trade. We as trade unionists have a great deal at stake in this war, because we have suffered along with other trades, from the unfair competition of the Germans. They will copy trade-marks and everything else, make an inferior article, and flood the world with it, and we find we cannot compete, and our trade goes to the dogs. These things ought to make us determined to win at all costs. It is better to die fighting in a good cause than to endure life-long slavery – which would be the case if the Germans conquered. We have all got sons or relatives in the fighting-line, and if we do not work for them and send them sufficient reinforcements to see this war through we are betraying them and sending them to an untimely death.

The Trade Unions had agreed to support the war effort by surrendering the right to take strike action because they thought the war would be short and their co-operation would be rewarded in peace time. As the war dragged on wages failed to keep pace with rising rents and prices and many workers found they had no power to take action. The introduction of mechanisation into munitions production made it easier for women to take on more tasks and harder for skilled male workers to argue they were indispensible.

Conscription soon began to impact on the local works as the *Warrington Guardian* reported,

> The withdrawal of so many able-bodied men has increased the strain on the industrial community but the spirit of unity has prevailed ... The war is being waged in the munition factory with all the resolution at our command. Week by week, month after month work goes on unceasingly. Holidays are surrendered in order that the men in the trenches shall be supplied with munitions to fight the enemy.

This determination to meet essential production targets led to the cancellation of the town's annual Walking Day in 1916 despite initial hopes that it could be rescheduled to keep up public morale.

Following the introduction of conscription Warrington firms which had been contributing the indirectly to the armed forces found it increasingly difficult to keep their male workforce since they were not always regarded as a priority employer.

Richmonds' annual report for 1917 revealed that 'Richmonds' gas furnaces have mostly contributed to the output of munitions and armaments of all kinds.' The company was also supplying large cooking apparatus for use in works canteens e.g. at munitions works, military hospitals and YMCA centres. Richmonds' also claimed the introduction of gas cookers and gas fires into homes helped to reduce the numbers of domestic servants making them available for munitions works. However, production was suffering because 400 men had been called up.

Employers like Richmonds' could apply to the military tribunals which were set up to examine the cases of all those who claimed exemption from conscription. Workers in key areas such as munitions were not allowed to leave their occupation and employers often managed to argue that specific front line workers were indispensable.

Robinson, Son & Co., glass manufacturers of Bank Quay, appealed for exemption for eight of their employees – seven engaged in the works and one who was a cost and wages clerk who had been with them for nineteen years. Mr A.J. Allen who represented the firm stated that they were makers of glassware for the Admiralty and for the principal steamship companies. They also manufactured navigation lantern lenses, while a large proportion of their trade was in glassware for the Army messes. The workmen, Mr Allen explained, worked in sets of three, and if one had to go it prevented the set from working. 'The scarcity of labour in the trade was remarkable. There was not a man to be got.' Conditional exemption was granted in every case.

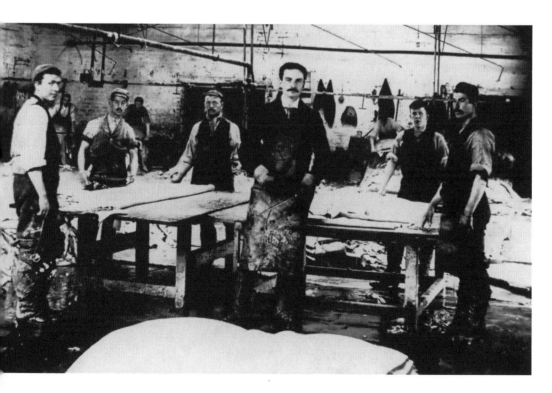

Several Penketh tannery workers claimed exemption from conscription in 1916.

Individuals could also appeal to the Tribunals for exemption from conscription on religious grounds but the tribunals were often unsympathetic regarding it as their patriotic duty to reject as many claims as possible and public opinion regarded 'conchies' as shirkers . Several workers from Penketh Tannery claimed exemption as there was a strong Quaker tradition in the area. One twenty six year old tannery worker told the tribunal that, 'He believed all war to be contrary to the teaching of Christ and because he believed in the Fatherhood of God over all men. Human life was sacred under all circumstances and he denied the right of the state to compel him in a matter of moral belief and conscience.'

He also claimed exemption on the grounds that he was the sole supporter of a paralysed father who would never work again and had a sister to maintain. Possibly his family circumstances gained him exemption.

Tribunals were less sympathetic to conscientious objectors who rejected any form of war service (e.g. acting as stretcher bearers). A small proportion of conscientious objectors refused to take any kind of war related role, arguing that to do so was to legitimise war instead of pacifism. The wartime Coalition Government did not want to make martyrs out of the pacifists including those who opposed war on religious or moral grounds and left-wing politicians who believed that the war was a capitalist conspiracy against the working classes. Charles Dukes was determined to take a stand and his case attracted nationwide attention.

His case was referred from the local tribunal to the Salford Appeal Court in August 1916 where he affirmed that his grounds for exemption were political rather than religious and his convictions were based upon, 'the moral concept that in the right and wrong of social progress war is never justifiable'. The National Union of Gas Workers and General Labourers had also appealed on his behalf, claiming that his role as a full time union official made him indispensable. Dukes maintained that if his claim had been based on his union work rather than his political views he would have been given exemption and implied he was the subject of unfair discrimination. The tribunal lost patience; his appeal was rejected and he was conscripted into the Cheshire Regiment.

Dukes refused to sign the enlistment papers and claimed that he was subsequently ill treated by two Non Commissioned Officers (NCOs) who tried to bully him into submission. He refused to obey military orders in the knowledge that this would lead to a court martial where he was sentenced to two years hard labour. Dukes then contended that he was refused military representation at his later hearing and questions were raised in the House of Commons about his case and the conduct of the NCOs by Warrington's Conservative MP, Harold Smith. However, Dukes lost his case and served his prison sentence. While some admired his stand many local workers – and even some of his trade union colleagues – regarded his actions as unpatriotic.

If Dukes was seen to shirk his duty, Warrington's women stepped forward to play their part. From mid-1916 women were called on to fill key gaps in the labour force. In the years immediately before the war the attempts of militant Suffragettes to win the right for women to vote had made the government wary of women taking on an active role in society. Now women were actively needed to take on roles traditionally reserved

Charles Dukes.

for men. The *Warrington Guardian* 15 March 1916 printed a letter from Councillor. Roberts in which he recognised that, 'One of the most striking and important and gratifying circumstances resultant from the present terrible war had been the noble, unselfish and patriotic part the women of the country had taken'.

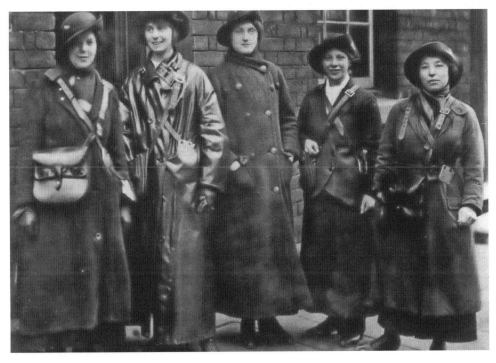

Women 'clippies' pose outside the tramways office in Cairo Street.

At first the government had encouraged women to retain their traditional domestic role and support the war effort by knitting socks for soldiers or sending aid parcels to the troops. Some better educated women sought a more active role by joining the Volunteer Aid Detachment (VAD) training as nurses, which was in effect an extension of women's traditional role as carers. Now the government conceded that women could take on roles such as clerks or later post women or clippies. Once the munitions shortages emerged there were more openings for women in factories and the introduction of new machinery meant that women were able to take on tasks previously done by skilled men or which required more muscle power.

Some Warrington firms like Armitage and Rigby traditionally had a higher percentage of women workers while in his diary entry for 3 May 1915 John Paul Rylands noted they had appeared in the wireworks, 'We have about 200 girls working in the mills and they look picturesque in coloured mob caps which keep the dust from their hair.' Lillian Evans, the Welfare Superintendent of the St Helens Cable and Rubber Co. Ltd. Warrington produced useful advice for the new female workforce and particularly those who would be undertaking heavy manual work for the first time.

Remember that you must be prepared to face all weathers. Keep special clothes for work and the plainer they are the better. Never wear stiff, tight, corsets. They induce dyspepsia and digestive troubles of all kinds; they compress the ribs and internal organs and interfere with proper breathing. Suitable work clothing

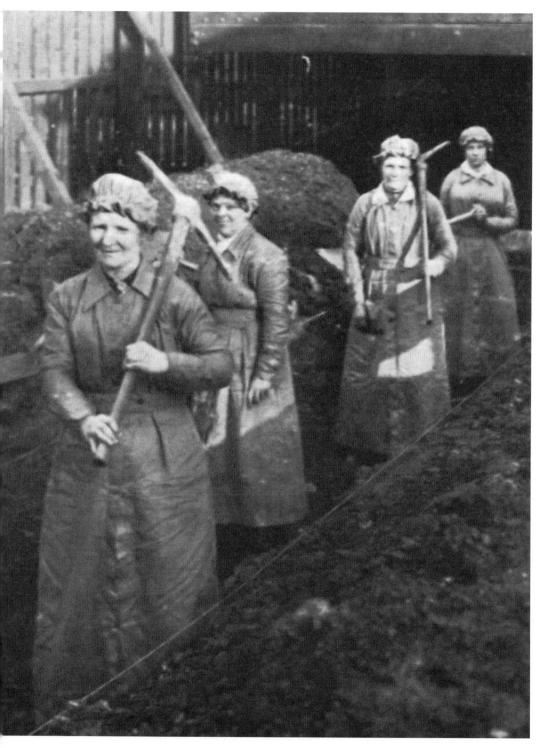

Women workers at British Aluminium wearing the traditional working dress of mob cap and overall (also worn by the Whitecross women on the back cover).

should include: A woollen combination, high necked and short-sleeved, thick or thin, according to the season of the year and the temperature of the establishment where the work is performed. Soft-easy fitting corsets with suspenders. Cloth or tweed closed knickers, not too thick in texture, with removable linings for washing each week ... A short garment of the Princess petticoat style, made of print or sateen ... or in a hot factory a thin camisole will be sufficient without an under-skirt ... The dress should not reach below the boot tops i.e. about eight or ten inches above the ground. About 2 and a half yards around the skirt edge is sufficient ... Stockings should be of cashmere or home-knitted ones. Semi-transparent, artificial silk or openwork stockings are an abomination in the work place. A fairly stout make of boot or shoe, with a firm sole and medium heel ... The regulation overall and cap will, of course, be worn.

Sensible outerwear was also a necessity with a thick warm coat for winter and waterproof for all year round protection but 'never be guilty of wearing picture hats or similar head-gear in which to go to work; it is the essence of bad taste'.

The issue of appropriate dress for the workplace was not the biggest challenge facing the new female workforce. The unions and male workers often resisted the introduction of women workers, fearing the reduction of wages if employers saw that a job could be done by girls. Women often out-performed men in tasks needing dexterity rather than strength but employers paid them lower wages because they regarded them as temporary substitutes. Employers were reluctant to invest in training them because, once the men returned from the front, they expected that the women would get married and leave. The employers also resented having to invest in new facilities such as canteens, wash rooms and toilets for this temporary workforce. If working mothers neglected their home and family to do their war work they were seen as unfit mothers; if they took time off to do household chores such as washing they were seen as unpatriotic by their employers.

However, women workers had became even more crucial to the war effort by mid-1917 as the army wanted a further 100,000 men a month for planned military offensives so the labour shortage was getting worse. During 1918 the upper age limit for conscription was raised to 50 and men were even taken from munitions work with the tribunals' exemptions being even more closely examined. Fortunately the US troops began to arrive at the Front and by mid-1918 there were signs that the German offensive was waning. If the war had dragged on into 1919 the manpower levels in Britain would have been critical both on the war front and at home.

CHAPTER 5

ON ACTIVE SERVICE 1915–18

Many of Warrington's soldiers were sent to fight on the Western Front and in the 475 mile line of trenches which stretched from the North Sea to the Swiss Border. Most found themselves in Flanders (Belgium) and especially near the town of Ypres. Warrington's 4th Battalion South Lancashire recruits arrived in France early in 1915 and found themselves in a quagmire of mud and hastily drug trenches while their headgear gave them little protection from snipers. Even those troops who more battle-hardened found the reality of life in these theatres of war to be a new experience.

In the early months of the war soldiers were able to send home detailed letters to their loved ones back home and many of these were printed in local newspapers. As the war progressed soldiers' letters were usually heavily censored to prevent them giving

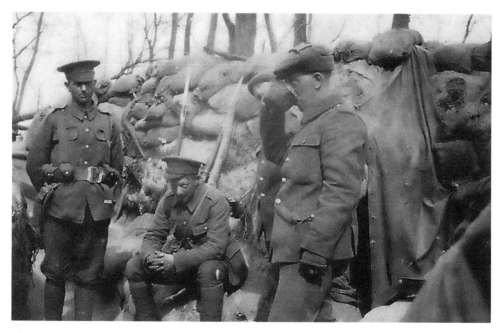

The reality of life in the trenches February 1915. © Lancashire Infantry Museum

away information which could be of use to the enemy. Newspapers virtually became propaganda agencies for the government and often limited themselves to printing up-beat stories from the trenches which soldiers who were at home on leave or for convalescence eventually had difficulty in reconciling with their own experiences. The *Warrington Guardian* regularly printed letters from the front as if the soldiers were acting as their foreign correspondents. The press often referred to the men as 'Tommies' derived from Tommy Atkins which was a nickname given to an ordinary British soldier since at least 1815. The War Office used this name on a sample form (like using Joe Bloggs instead of a real name) and stories of Tommies in the Trenches became a popular feature in local newspapers.

In January 1915 the *Warrington Guardian* printed a letter from by Pte J. Tozer who was serving with the 9th Devon Regiment to try to relate life in the trenches to their readers' daily lives.

> You asked me to tell you what it is like out here. Well the best way I can describe it is this. Go out in your back garden, dig a trench 7 foot deep, 3 foot wide, fill it up half way with water. Get up at two o'clock in the morning, put the coal scuttle round your neck, walk around the town for four or six hours; then go to the trench, get in it and stop there for four days and nights. For the excitement of being under rifle and shell fire get your next door neighbour to throw a bottle or lump of stone at your head every time you put it over the top of the trench. That's the best way I can describe it.

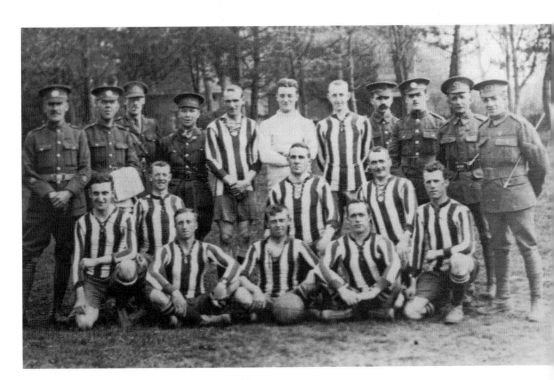

Captain Anderton at rest (front row left).

Capt. Robert Anderson was well known to local readers because of his connection to the town's rugby league club so his report from Trenchland in the spring of 1915 seemed to have an added authority:

> At the time of writing (31 March) over half of the battalion are doing their second turn of 48 hours in the actual firing line since Friday last and I think we will have earned a little rest going out tomorrow night. Our boys are taking to this trench warfare like ducks going into water and they are up to all kinds of pranks. As I write the enemy's artillery are trying to locate a position just behind us and shells are flying over us, but from what I have seen they cannot hold a candle to the English.
>
> One thing that will amuse our friends in Warrington is to see us on moving off from headquarters to the trenches. We resemble walking stores; some carrying eatables such as bacon, bully beef, biscuits, jam, cheese, tea and sugar, whilst others struggle along with cake, wood, bottles of water and numerous other things which make the trenches a little more like home. On arrival there we make ourselves perfectly happy. At meal times our boys go in for all kinds of experiments. One is to soak a mess tin full of biscuits and boil with a quantity of jam mixed in. This is called *plum duff* and it makes quite a tasty bit. By the way one of my luxuries in bacon fat. It is great!

As 1915 progressed life in the trenches seemed much more organised and those back home often did not realise that their loved ones did not spend their entire time in a front line trench. In fact there was a system of trenches with firstly the front line or command trenches (where the officers were also based.) Next came the support or communication trenches (further back, where the signallers were based and where fresh supplies were brought by horse drawn wagons.) Lastly there were the Reserve trenches 500 yards further back where reinforcements waited to join the action if needed.

A Tommy usually spent one week per month in the Fire trench; one week in the reserve trench and was then moved behind the lines to a billet. Here could be found the relative luxury of a straw bed; bath, clean clothes; a hot meal; an opportunity to catch up on news from home and possibly an opportunity to get a drink in a local bar or to socialise with local women. The reality of life in the front trench meant mud walls reinforced by rows of sand bags; a hasty meal of lukewarm stew made with 'bully beef' and biscuit rations (which were like dog biscuits) and the presence of rats scavenging for food (or even corpses.) In addition, there was the ever present noise of shells overhead and sniper fire that meant '*Keeping your head down*' below the parapet or else risking death at any moment.

Sgt Walter Griffiths of the Warrington Territorials gave a vivid impression of life in the battlefield digging trenches under fire in March 1915.

> Friday night was a most terrible night. To be in the trenches is bad enough, but to be under rifle fire, start a trench and dig yourself in is going one further. We started away from here at tea time and walked a distance of about five miles. By the time we had gone three miles it was pitch dark, and for this we were very thankful even though we could not see where we were going.

We advance in single file, one big long string of us, and you must not lose sight of the man in front or you are lost. We make our way slowly and carefully, everyone speaking in whispers, with now and again a stray bullet whistling over us. On we go nearer and nearer until progress is more difficult. Now the star shells begin to illuminate our whereabouts, and it is as light as day – just as though a flashlight photograph was being taken, except that the light holds out for about a minute; then up goes another. We lie down or crouch in a ditch for (or so it seemed) fifteen minutes, the bullets whistling or cracking over us all the while. There seem to be three kinds of bullets, one a kind of whistle; another a swish, and the third an explosive bullet, which goes crack over your head.

Now things get quieter, and we have another run for 300 yards or so. This we do a number of times before we reach the place where the trenches have to be dug. We now leave the path and cross the fields, stumbling and swearing over the banks, then the ditches – splash, splash over the knees in liquid mud. After another long stop, during which men are lying down in six inches of water, we move on again until we reach our destination, and the men are only too willing to set to and dig themselves in.

Going home, it was easier to pick our way since the moon had now been up a couple of hours. I was never so tired. We were like a regiment of drunken men, crawling along. We dare not halt or else we should have fallen asleep. One thing we longed for was a smoke but we were forbidden to smoke all night. However, we got back more asleep than awake, and after a cup of tea had a smoke got down and slept until dinner.

The most dangerous place for a soldier to be was in no-man's-land. Local sapper Harry Mason of the Royal Engineers gave a vivid account to the local newspapers of repairing the trenches and getting caught between the enemy lines.

It is our duty to make the trenches habitable; to keep them in repair and also to lay barbed wire entanglements. The last named is the most dangerous job of all. I might mention that I have helped to lay many a mile of Rylands Bros barbed wire out there. The trenches are made comparatively bullet proof by means of sand bags and earth. Our work is largely done in the space between the trenches … and in order to escape the attention of the enemy we have to be particularly active during the night. When the Germans suspect we are busy they send up flares and it generally means a bullet for any man who happens to be standing up.

The British and German trenches were in close proximity to the main road and each was equipped with a Maxim gun. Four of us went out to lay barbed wire and while we were at work about midnight the Germans made an attack. Both sides opened heavy fire and we four Engineers had to lay down flat in a ditch in about 6 inches of water for about four hours. The Germans never got near our barbed wire. They were driven back by rifle and machine gun fire. When it was over we crawled back to our trench where we were well received. The sergeant expressed amazement that we had escaped at all.

Repairs to the trenches were also carried out in daylight hours and by 1917 the soldiers had settled down into an organised routine while they were in the front line as another sapper described in a letter to his parents printed in the *Warrington Guardian* of 6 October 1917.

Just imagine you are in a small dug out made on the side of a valley about three miles from the city of [blank]. The time is 7.30 am. We are having breakfast consisting of bread, tea and toasted cheese. At 8 o'clock we fall in with fighting kit, tools etc. We proceed for about half a mile … before we go down the trench look around and you will see a beautiful panorama of the city of [blank] lying in the hollow, with its cathedral ruined and broken, glistening in the sunlight. Now we have a monotonous walk of perhaps a mile on duck boards, passing on our way some big howitzers, captured by the [blank] regiment from the Germans. Coming once more into a valley we suddenly come across a tank, which has seen better days, having done its bit.

Across the road the trench starts again. Here you see life underground. We pass parties of men, some carrying duckboards, galvanised sheets, rations and water, while those who live in the trenches are cooking, shaving, rifle cleaning, or just engaged in different jobs. All at once we hear a roar like a train going into a station. It is Fritz trench-mortaring us. Anybody hit? No, carry on. Or perhaps some luck dog has got a piece in his leg. Smiling all over his face he mutters 'Blighty'. Well we reach our job. It may be in the front line, repairing parapet or fire steps, or it may be in support. Anyhow you have plenty to do until 4.30 p.m. comes. Then you pack up and on the way back you perhaps have a look over the top, wondering when the next bombing stunt will come off.

Well we are back, safe and sound at last, thanking God to be safe and sound for another day. 'Dinner Up!' is the cry and a good dinner well earned it is, consisting of meat, fried potatoes, beans and pudding. About 7 o'clock comes tea, generally tea, bread and butter, jam or fish. Afterwards we have a wash and if not on guard or other night duty can turn ourselves in.

After their allotted time in the front line trenches the soldiers had several days behind the lines billeted in a nearby village. The army soon realised that the troops would need recreation facilities and the YMCA stepped in to provide a series of Recreation Huts at the base camps in France. In February 1915 the *Warrington Guardian* reported that Lady Greenall would be going out to the Front to,

Take charge of a refreshment buffet to be opened under the auspices of the Auxiliary Committee of the Recreation Huts at the base camps in conjunction with the YMCA. Lady Greenall has this week visited the War Office in connection with her new duties and has also had an interview with Princess Victoria of Schleswig Holstein, who is President of the Auxiliary Committee. Her ladyship will be accompanied by a staff of assistants.

Lady Greenall proved to be no mere figurehead and her buffet became known as the Walton Hut. In Feb 1917 the *Warrington Guardian* carried an article by Sgt Box of Egerton Street, Howley serving with the Border Regiment describing the Walton Hut.

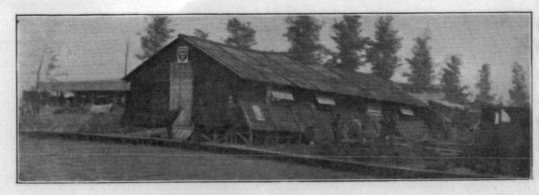

Church Army Recreation Hut on West Front, damaged by German Shell.

Church Army Recreation Huts, Tents and Clubs at the Front.

A church army hut similar to that run by Lady Greenall.

By opening time, 5 pm, the place is packed with soldiers of all regiments, English, Irish, Welsh, Scotch and colonial ... and from then until closing time of 8.15 pm, five assistants are at work as hard as they can possibly go dealing out from the counter. It is a sight to see the piles of bread and butter and cakes disappearing, but when hot pot or hot bread pudding and sauce are on, then there is a sudden clearing. One has to be out here in this weather to realise how welcome is a hot meal of any sort, or a cup of hot tea or Oxo.

During the week there are concerts given by various parties, and some excellent talent appears. On other nights there is generally someone who can play the piano and the time goes pleasantly in dancing. I omitted to say that a fine painting of Walton Hall by Mr Dell decorates the drop scene on the stage. With regard to the reception of visitors to hospitals this hut is doing a grand work. When a soldier is so seriously wounded that his life is despaired of the War Office writes to the nearest relative, giving them permission to visit the place. (The relative then comes to France under the care of the YMCA and is lodged in a hostel near to the hospital.) The Walton Hut is the nearest hut to a series of military hospitals and the work is to receive visitors from the hostels and give refreshments and a place to rest until they can visit the hospital.

The time out of the trenches was a good opportunity to catch up on welcome news from Warrington. George Whitfield, a former teacher at Arpley Street School discovered that he was being greatly missed by his former pupils in this touching letter from William Bibby, his former school monitor.

Dear Sir, I received your letter and photo last Thursday. I am getting on well at school but I have had the cane many times. I am glad to think that you are not far from us.

George Whitfield.

I have had no time to write as I have been at a sale of work all last week. I did enjoy myself. Mother had a stall. We only wish we had you back again. If we had you back again we would let Mr Hands go. I thank you for the photo. None of us like Mr Hands he is so nasty. We have had some fun in the snow and hailstone. Are you living in huts or tents? I thought you had forgotten me. Jack Murray was delighted with the letter and photo and Jack Isaac was the same. I must now close as time is short. We all wish you good luck and safe return, From your loving monitor William Bibby.

Army records show that Whitfield of No. 57 Gaskell Street had joined up on 22 October 1915 at the age of 23 years and 7 months with a height of 5 foot 5 inches and a 35 inch chest. He is described as a storeman rather than a school teacher. He was later transferred to the Second 4th Battalion of the West Riding Regiment and appointed a Lance Corporal but without pay.

Meanwhile many former members of Warrington's Church Lad's Brigades were also serving in the armed forces at the outbreak of the war. This was largely due to the influence of Revd Bracecamp who had gone to France as Chaplain to the Warrington

Harry Goodwin in his
Church Lad's Brigade
uniform.

Territorial Regiment in June 1915. Over a hundred past and present members
of St Paul's company followed him into action. Among them was Harry Stephen
Goodwin, who had joined the brigade at the age of thirteen and had the honour of
representing the Brigade in London at the coronation of King George V.

By April 1915 he had risen to the rank of Sergeant in C Company of the Warrington
Territorials when he was wounded in action. His father, John Goodwin of Froghall,
news received reassuring news from his superior officer that,

> You must not worry, as the wound is only a flesh one, Harry was sitting in a dug-out
> when a bullet came through the roof and struck him in the fleshy bit of the right
> thigh ... He asked me to write to you so as not to cause you any alarm if you heard

any rumours floating about. He was in good spirits, spoke of you all at home, and smoked several cigarettes with me before his removal to hospital. I expect he will be home in a month or less.

Sgt Goodwin returned to duty, transferred to the new Royal Air Force where he was promoted to First Class Mechanic and Flight Sergeant and having served his country returned home at the end of the war to resume his career as a cabinet maker.

Warrington families also received letters home from the trenches, although as the war progressed they were only officially allowed to send home brief postcards with a series of phrases they could select as appropriate and which had to be passed by a censor. This was partly to prevent important intelligence falling into enemy hands but also to avoid lowering morale at home with bad news from the Front. Writing home on 30 May 1915, shortly before he was killed in action, Cpl Peck of the 2nd South Lancashire Regiment described the devastation around him near Ypres in Belgium.

I am just a stone's throw from the biggest ruin in the history of war – a place which has not a single building that is not damaged, yet only a short time ago it was a city with fine squares, fine buildings and a big population. I have passed though it a few times lately, and to see the ruins, the shell-marked square, the burning buildings ... that's war, one of its aspects. Take an ordinary English village and walk through it at the close of a nice summer's day, and what do you see? Nice cottages, children playing round the doors, cottagers tending their gardens, clean streets, quiet by-lanes,

166. La Grande Guerre 1914-15 — Aspect de LA BASSÉE (Pas-de-Calais), après les combats héroïques et victorieux qu'y soutinrent les alliés A. R.

A postcard home showing the devastation of war.

a quaint country church ... Now change that place to Belgium. Again we have a country village but ... the cottages are in ruins, the villagers are gone, the church is levelled, all but the crucifix ... The crops and pasture lands are in just about the same state. They are torn by shells everywhere and trenches run in almost every direction.

By early 1915 Warrington's soldiers were facing a new deadly danger in the trenches as the Germans began to use gas attacks. Driver John Walsh, son of Mr & Mrs J. Walsh of No. 29 Fothergill Street, had a lucky escape from a gas attack in June 1915 as the *Warrington Guardian* reported.

We had only been here a day when about one o'clock on Sunday morning they came over the parapets and made an attack. But they did not come without sending the gas. They got as far as our front line trench and then every one of them was bombed out. Not a single German got back alive. The attack was on a front from about 200 to 300 yards ... I can consider myself lucky after that night. We had our gas helmets on and we got orders to take one load of ammunition up to the guns. The night was lovely, with just a light wind in favour of the Germans using their gas. And my word it came

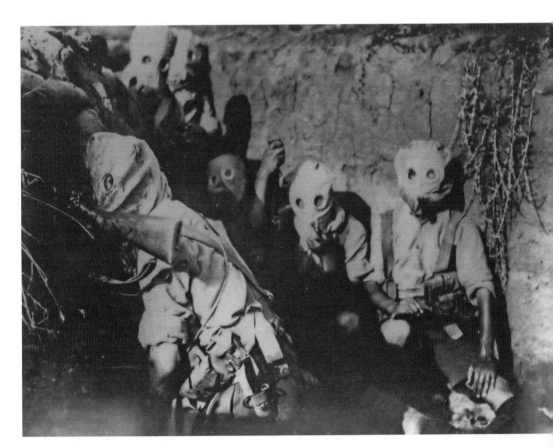

Troops wearing the protective cloth gas helmets issued in 1915.

over too. We got the alarm about half an hour before it reached us. The bells began to ring and the hooters began to blow. Everyone knows when it is gas … There is one kind of gas which is very awkward and deadly. There is no smell attached to it and the only thing we can tell it by is by our listening posts hearing them sending it away from their trenches. It comes with a hissing noise. The sergeant – major told me to harness up at care and take ammunition up to the guns which were covering the infantry on the front where the attack was being made. We set off with the wagon and got on to a narrow road which leads to a place where the guns are in action. The Germans were still sending their big shells and also gas shells. We could hear them whistling over the top of us. Suddenly one burst alongside our horses. I ducked and it was a good job I did because I would have been tangled in the telephone wires which the shell had broken. Well I was lucky. The horses made one leap and tried to get away but I had them beat.

In June 1915 the harsh reality of warfare struck home for many more Warrington families when the Warrington contingent of the 4th Battalion South Lancashire Regiment suffered devastating casualties on 16 June in an attack on German trenches at Bellewaarde near Hooge just outside Ypres in Belgium. The day's objective had been to capture Bellewaarde Ridge from the Germans because it gave them a vantage point over the surrounding area to the east of Hooge. Several regiments were involved in the assault which should have taken place in a series of carefully planned waves, beginning just after dawn under the cover of heavy artillery bombardment of the German trenches. In the second wave Major Egerton Fairclough led some of the First Battalion to try to capture the road from Hooge to Bellewaarde while other Warrington men were part of the wider advance.

Disastrously for the 4th Battalion, the carefully orchestrated battle plan was falling apart. Men were advancing too fast before their own artillery bombardment had ceased and they were also being fired on in the German counterattack. While Egerton Fairclough's contingent held their ground as long as possible, in the heat of the action their Warrington comrades were taking heavy casualties. The local newspapers later reported dramatic eyewitness accounts like those of Pte Fell who described it as 'Hell Let Loose'.

I can thank the Lord that I am able to write you these few lines letting you know that I am quite safe after a most terrible engagement in which we bravely took our part. Our boys charged along over the parapet, led by the colonel and others by the major, right through the German trenches. Oh it was a grand sight to see all the regiments mixed up, dashing along. 'Scotties,' Irish Rifles, Fusiliers – all sorts – scattering Germans and capturing them by the score. You should have seen them putting their hands up and shouting 'mercy, Camerons.' But they gave them mercy.

Oh, the noise of the bombardment! It was terrible. Nothing but bang! Bang! Bang from three o'clock in the morning till we got relieved at midnight. With the Germans retiring they had the range of our trenches and my goodness they did not forget to shell us. We lost most of our officers and men by shells, more than by bullets. But you should have seen the damage our artillery had done. Their trenches were filled with dead and wounded. It was pitiful to see your own pals getting blown to pieces by the side of you … It was hell let loose.

TERRITORIALS IN A BIG ENGAGEMENT.

HEAVY LOSSES: 27 KILLED, 221 WOUNDED, 8 MISSING.

HIGH PRAISE FROM THE BRIGADIER.

"You have proved that the 4th South Lancashires 'Can Never be Broken."

Local newspaper headlines of the Battle of Bellewaarde.

Elsewhere Pte Miller witnessed many of the 4th Battalion's casualties.

Our company has lost an awful lot for we were first in our battalion ... I was in the second German trench when I was bowled over by the explosion of a shell. A piece struck me in the back of my left hand and ended my career in the fight ... My section commander, Corporal Ince was shot dead just as we reached the trench from where we started. He was a brave and splendid soldier. His last words to his section were, 'take no notice of the sights you may see. I know it will be hard to keep passing your chums when they are wounded, but remember, duty comes first, and we must not stop until we have reached our goal.'

I shall never forget the sights I saw on that bloody battlefield. In fact when I had been hit I thought I would have been bowled over again before I reached the dressing station, which I was about a mile away. It was marvellous how I escaped for it was simply raining shells the whole time and the German Maxims (machine guns) were spitting out death as hard as they could. Many a poor chap who was making his way out of it like me never reached the dressing station.

Part of the Fourth Battalion was virtually wiped out in the day's action which failed to achieve its military objective. As the *Warrington Guardian* reported, 'The toll of life was heavy; Warrington had many darkened homes in the days following ... but mingled with sorrow was a feeling of pride that the local Territorials had so signally proved their mettle in a terrible ordeal.' G. R. Crosfield, by now promoted to major, was considered to have 'set a fine example of coolness and bravery under most dangerous conditions'. The Brigadier General described the 4th Battalion as 'The Unbreakable 4th' for their part in the action of the day in an effort to boost morale, but this could not disguise the fact that twenty seven local men had been killed on one day, and at least 220 were injured with others still missing in action.

It was hard for the town to accept that so many of the local volunteers they had waved off to battle so cheerfully a few months ago would never return.

Until the mid twentieth century Warrington remembered the events of Hooge Day with an annual parade through the town by the South Lancashire Regiment on the anniversary of the battle. Although Warrington men would serve in nearly a hundred other regiments during the First World War the fate of the South Lancashire regiment continued to hold a special place in the town's heart.

As 1915 wore on it was not only the families of those serving with the South Lancashire Regiment who received bad news of their loved ones and it was an especially difficult time for families with more than one member of the family serving. In November 1915 the *Warrington Guardian* carried the story of the Kent family of Hoyle Street:

> Private Harry Kent of the Gordon Highlanders, the eldest of the four soldier sons of Mr. H. Kent of 42 Hoyle Street, Warrington, has died in hospital at Rouen of wounds received on October 3rd. Private Kent came safely out of the heavy fighting on 25 and 26 September, but was injured the following Sunday in the abdomen and hip. He made good progress for a time but blood poisoning supervened and he died on Thursday 4 November. Private Kent has been buried in a French cemetery set aside for the interment of British soldiers who die from wounds Two of the other three soldier sons of Mr Kent Senior have also been wounded and are in hospital. They are Private John Kent of the Gordon Highlanders, who is making good progress, and Private Ernest Kent, of the Warrington Territorials, who is in a Blackpool hospital. The Third Son is Corporal Joseph H. Kent of the Territorials who is at the front.

As 1915 drew to a close it was clear there would be no swift end to the war which was becoming a worldwide conflict. Even at home the effects were felt as work on the building of Warrington Bridge began to be affected by a labour shortage. The *Warrington Guardian* now carried reports of Warrington men in different theatres of war: 'Men from this district are doing their duty nobly in practically all, if not all, the sphere of operations – with the Fleet on the high seas, in Flanders, in France, in Gallipoli, in Egypt, in Africa, and in the Balkans.' Other Warringtonians found themselves caught up in the action even if they were not serving in the armed forces.

Warrington shared the outrage at the sinking of the luxury passenger liner *Lusitania* by a German U Boat on 7 May 1915 off the west coast of Ireland. 1,198 people were killed and one local man was involved in the drama. John McStay of No. 71 Dallam Lane was on his fourth voyage on the ship and later gave this dramatic account to the local press.

> I was down in the stokehold when we heard the crash. We knew something was wrong and rushed to the deck where we stood by the boats. Everyone on board was calm and collected; the only whimpering from the terrified children. I jumped into the water and had been swimming for some time when I was picked up by a boat which was crowded, mostly with women and children. It was very calm at the time and this enabled the rescue work to be carried out more readily. I was in the boat for some time before we were taken on board the steamship which took me to Queenstown.

The sinking of the *Lusitania* made good anti-German propaganda.

Just after the torpedo struck it was terrible. Men, women and children were floating on the surface like so many corks, and it was horrible to see them struggling for life. The children, who on board had been the only ones to cry, were quite the opposite when in the small boats. They jabbered away as if nothing had happened and as if they were going on a picnic. In our boat there was an old lady of 83 years and she was bearing the ordeal admirably. Everybody attempted to get away from the giant vessel before she plunged under the waves and away from the suction this would cause. But I was surprised that there was hardly any worth talking about. We would not be more than 50 yards away when the vessel slided below. I saw the submarine come to the surface but it was only for a second or so; seemingly she wanted a look round and then she disappeared.

Soon there were many boats coming to the rescue and those in charge gathered the bodies, dead or alive. There were many acts of heroism and there can be no

Trench warfare in the Dardanelles campaign.

exaggeration that one sailor must have picked up at least 100 people, but many of these had been found dead. When we alighted at Queenstown we were met by a huge crowd who cheered us and everywhere we were received with the greatest kindness.

By the Spring of 1915 several key British politicians felt the war on the Western Front had reached stalemate and decided to try to weaken Germany by an assault on Turkey which was one of her allies. Success would provide the Allies with an easier supply route to Russia via the Dardanelles. The campaign proved a disaster almost from the start and many Warrington men found themselves caught up in the ill-fated Gallipoli landings and the disease-ridden trenches of this new war front. One victim of the campaign was of Private Thomas Gaffney of No. 24 Kerfoot Street who was previously employed by Pearson &Knowles at Bewsey Forge. Gaffney was killed in action in the Dardanelles on 11 June while serving with the 1st Battalion the Border Regiment. A letter home from his comrade Private Nicholas which was printed in the *Warrington Guardian* gave a vivid description of the action.

On the day of our landing in the Gallipoli Peninsula we forced our way inland for about 400 yards from the beach, and then we entrenched. During the night the enemy attacked us in thousands, and after about two hours fighting we began to run short of ammunition. Tom volunteered and went to the beach under a storm of bullets and came back loaded with ammunition. For this service he was placed

4th. S.W.B. Died in Turkish Hospital from Dysentry Aug. 21st. 1917.

John Milner.

John Milner, who died at Gallipoli.

on the Commanding Officer's staff as fire officer. A few days after this there was a general advance by the whole of our division and of course Tom accompanied the Commanding Officer, who was then acting as Brigadier-General. During this advance Tom again did some valuable service by going back for reinforcements under heavy fire. During the day Tom and the CO got to within about twenty yards of the enemy trenches and unfortunately the Commanding Officer was mortally wounded by a German officer. Tom immediately shot the German officer and again immediately returned for reinforcements ... Tom was killed in action on the morning of Friday 11 June. It may lighten your sorrow to know that his death was painless and instantaneous, as the bullet entered his forehead and penetrated his brain.

However, the majority of Warrington men in action were still serving of the Western Front and as January 1916 dawned the British Government effectively admitted that Kitchener's strategy of relying on a volunteer army had failed by beginning the process of introducing compulsory military service or conscription. As there was still opposition from some quarters to the idea of conscription in October 1915 the new Director of recruiting, Lord Derby, introduced a scheme which still allowed men age 18–41 to volunteer but invited others to 'attest' or give a signed promise that they would enlist if called on. By mid-December just over two million men had attested but

only 215,000 had actually enlisted. This was far short of the target needed and the government calculated that at least 650,000, including many single men, had neither volunteered nor attested.

Given Lord Derby's pre-war support for the National Service League it was perhaps not surprising that the government's next step, in January 1916, was to pass the legislation necessary to introduce conscription. Despite the needs of the armed forces there was still opposition to the idea of compulsory service and anti-Conscription rallies were organised. A Warrington meeting at the Co-operative Hall ended in chaos when the speakers were drowned out by an audience singing patriotic songs because they felt that those opposing the government were also opposing the war. Resistance to conscription proved futile and every male between the ages of eighteen and forty one who was unmarried, or a childless widower with no other dependants was assumed to have enlisted for service in any unit designated by the military authorities. The scheme began with those who had attested for service under the October scheme although men could apply for exemption on specific grounds including their existing essential occupations to the new military tribunals.

The additional man power was badly needed as Germany adopted a more aggressive strategy. In early 1916 the German army launched a major offensive at Verdun. On 31 May the German navy was victorious over the British navy at the Battle of Jutland and in early June 1916 it was clear there were several local casualties among Warrington men serving in the Royal Navy. The *Warrington Guardian* printed this account of the experience of Robert Pilling of Laira Street. Pilling had arrived in Warrington quite unexpectedly at two o'clock on Thursday morning bringing with him as souvenirs fragments of German shells. Described as a wiry youth of 17, Pilling told the reporter of his experiences in an unemotional, matter of fact sort of way.

After we had been in action about three hours Admiral Sir John Jellicoe's fleet came on the scene and the Germans soon cleared off. We chased them on to their own minefields, and it is believed that some had to take refuge in neutral ports. There is reason to suppose that our ship rammed three submarines. Altogether we were rambling around for 24 hours before making it to port. Engagements between destroyers and light cruisers continued far into the night, the darkness being dispelled by the glare of searchlights. We had a report from our destroyers that they had much better of matters.

Another local man, Signaller Albert Stockton of No. 13 Helsby Street, a member of the crew of an attached cruiser of the battle squadron maintained that, 'If we had only been able to meet the Germans in a pitched battle they would not have had one ship left. The scene at night would have made a fine photograph, with ships ablaze and magazines exploding.'

On 1 July 1916 Britain launched a major offensive on the Somme which left 60,000 dead, injured or missing on the worst day in British military history. John Paul Rylands waited anxiously for news of his son Geoffrey, an officer serving with the King's Liverpool Regiment who he knew was involved in a significant event. On 16 July 1916

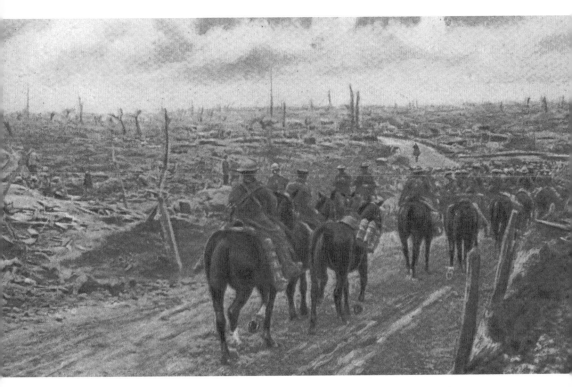

After the Battle of the Somme.

John Paul finally got news from Geoffrey who was resting for a few days in a small town not far behind the lines. Geoffrey wrote,

I have a bed and excellent food with a French pork butcher and his family ... Well it is such a treat after the time we have been having, which can as General Shea said to us yesterday, only be described as Hell. We have won a great name in the army and done great things but it has cost us many of the best men who ever lived ... We are doing well out here now and one can see some hope of the war coming to an end someday. Don't be alarmed when you see the casualties, we (the 17th) have lost about 400 men and officers but you must remember that the majority of these are only slightly wounded and we have had some very heavy fighting in the biggest battle the world has ever known. These are now nearly all replaced and we are ready to fight again and to do just as well My uniform is pretty well in rags after this and I have ordered another one from a little French tailor here who makes quite well.

One noted Warrington casualty of the Somme was George Thomas of the town's Rugby League Club. Thomas had joined the club in 1903 had a distinguished record, playing in four Challenge Cup finals and the first international rugby league match, representing Wales against Australia. He had volunteered for the South Lancashire Regiment in August 1914. He was killed at the Battle of the Somme on 3 July, when he received a

George Thomas.

direct hit from a German shell which his commanding officer reported blew Thomas to pieces. As a result there could be no military burial and he became one of Warrington's soldiers who as later commemorated on the imposing Thiepval Memorial in France.

As the war went on increasing numbers of Warrington's men were injured in action especially on the Western Front. The sniper's bullet or an exploding shell was a daily hazard in the trenches and the chaos of the battlefield brought new challenges in dealing with casualties. Soldiers were not allowed to stop and help an injured colleague. Each man had a field dressing fixed to his uniform to tend to his own wound. He was then expected to walk to the first aid post in the reserve trenches. More seriously injured men might have to lie on the battlefield for hours until it was safe enough for the stretcher bearers to rescue them. Serious cases were taken to the Casualty Clearing Stations behind the lines which could each deal with up to 2,000 cases and where immediate treatment such as amputations would be carried out by the surgeons on duty.

It was the officers' responsibility to write home to a family with news of the loved one being wounded or killed in action. Many of the officers were young and barely knew some of the men in their troop. As casualties mounted, the letters became increasingly hard to write and it was often kinder to write that the man would have been killed instantly and was much missed as a valuable member of his regiment rather than accurate news of terrible suffering or an indifferent soldier whose death went largely unnoticed. However, when Private Mercer was injured in March 1915 his family received a detailed account of the incident from Lieutenant Brian Dickson of D Company.

Stretcher bearers from the South Lancashire Regiment.

Six hundred men of the battalion went off to dig trenches 70 or 80 yards in the rear of those already occupied. The ground on which we were digging was supposed to be what is called 'dead' ground i.e. out of the field of fire, but as matter of fact there were a good many bullets flying round. Private Mercer had just started digging when he was shot in the right leg just below the knee. Lance-Corporal Foster, who is an ambulance man, stripped his knee and bandaged up the wound, and we made him as comfortable as we could in the circumstances. The stretchers were sent for, and he was carried back to the dressing station, and had the wound properly dressed by Dr Law. He has since been taken to hospital somewhere up country ... Pte Mercer is one of the best men in my platoon, and we can ill spare him. Only yesterday he was up for promotion to lance-corporal. He was exceedingly brave, and we gave him a small dose of morphia to ease the pain. I hope he will make a speedy recovery, and even if he is sent home, I think you will find him eager to return to his pals out here.

Mercer had had to wait for attention for it was not safe for the stretcher bearers to recover the injured during the daytime as Cpl Tom Isherwood explained in the *Warrington Guardian* in April 1915.

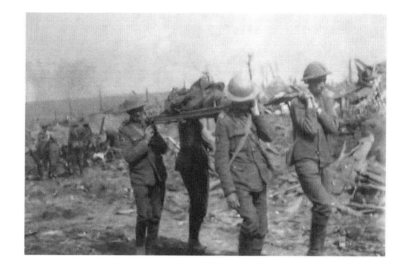

A grainy action photograph of an injured soldier carried from the battlefield.
© Lancashire Infantry Museum

The stretcher bearers don't stay in the trenches during the day. We do our work at night time. Bullets whistle past us in all directions. Our dressing station is about a mile away from the trenches in an old building … well it has been made to look old by the shells which have broken nearly all the windows and the roof. If any of the men are wounded in the daytime they telephone to us and as soon as it gets dark we go and get them in. Dr Law attends to them and in the early hours of the morning the field ambulances come and take them to hospital.

Seriously injured men were taken to the Casualty Clearing Stations behind the lines which could each deal with up to 2,000 cases and where immediate treatment such as amputations would be carried out by the surgeons on duty. One of the biggest dangers facing wounded soldiers was the danger of sceptic poisoning as even a senior officer could discover. On 31 March 1916 newly promoted. Lt Col G.R. Crosfield sent a very matter of fact letter to his sister telling her he had received a gunshot wound to his left ankle, fracturing both his leg bones while on duty at St Eloi. 'Isn't it a nuisance? I got shot just above the ankle when reconnoitring some ground with the Brigade Major. Bullet wound and compound fracture. I don't suppose I shall be fit for the field under three months.' Unfortunately the wound turned sceptic and a week later his leg had to be amputated below the left knee. This effectively ended his army career but not his war as he was later given a commission as an observer in the RAF.

The surgeons on duty on the first day of the Battle of the Somme were faced with unprecedented numbers of severely injured men and had to work round the clock as one later recalled.

We were all packed up awaiting the overdue arrival of the Australians to relive us in order to enable us to go south for the Somme push. Whilst we were waiting the Germans put on a heavy bombardment of the front line trenches and casualties began

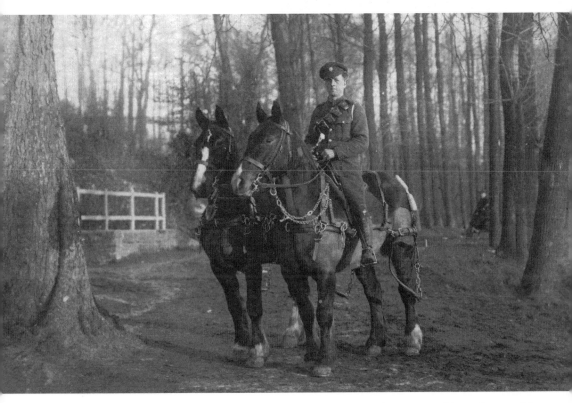

Myles Crozier with Hector and Sally who ferried munitions to the Front and brought casualties back with their cart.

to arrive so we unpacked all our equipment and set up a dressing station again. My ambulance was held in reserve but another in Albert had five out of ten medical officers knocked out with a shell (all killed) and I was sent to help. For 72 hours we carried on dressing the wounded as best we could and snatching sandwiches off a plate. We cleared our wounded and finally dropped down exhausted where we were and fell asleep. We lost some 8,000 out of 12,000 fighting men of our division in those first three days.

By 1916 a number of local women, including Geoffrey Rylands' sister, Dolly, were also on active medical service as nurses. The youngest member of the Broadbent family, Lucy, served with the Serbian division of the Russian Army as part of a Scottish Women's Hospital in Romania. Lucy found herself close to the front line in late 1916 in a unit staffed entirely by women and wrote home describing the action she witnessed as the Germans advanced near to their headquarters:

It is an awful thing to watch a retreat. The depression of it all is beyond words. On Saturday morning a Serbian officer came and insisted upon us going. Even then Dr T. chose one of the doctors and some of the nurses to form a dressing station. Some of

the others had had a dressing station nearer the front than we were all of the time and we had no news of them when we left Galatz (north of the Danube.). The transport people were also in another camp, and they had great adventures in escaping. We had the easiest time as we went by train, and our most exciting moments occurred when we stopped on a bridge at 10 p.m. and they said we could go on no further because of the guns, which were certainly very near. We could see the shells bursting and the villages burning. We only just got over the bridge in safety, for bombs dropped on either side as the train went across. After a two days' journey we got to Galatz and Dr — who has a hospital there gave us tents to sleep in. We got there on Tuesday and the following Saturday Clack and I were chosen to take some hospital stores to Odessa. We had an awful journey but finally arrived and had a warm reception from the English Consul and stayed in a comfortable hotel.

(As a result of this action Lucy Broadbent was later decorated with a Russian medal for bravery under fire.)

Despite the terrible casualties suffered by the British army at the Somme there was still stalemate on the battlefields of France and Flanders and even Geoffrey Rylands was becoming despondent, writing home to his father on 13 October 1916, 'The smile is very faint today. We attacked again yesterday and have lost a lot of fine officers and men. This war is really a most wicked and damnable affair and the sooner it is over the better. It is beginning to get on my nerves.' Warrington's soldiers fighting on the Western Front were destined to endure many more hard fought battles in 1917–18, including fierce fighting at Vimy Ridge; heroic action on the swampy battlefield of Passchendaele in the Third Battle of Ypres in July 1917 and in 1918 renewed offensives on the Somme and the final assaults on a weakened German army.

A rising death toll and loss of fighting men as Prisoners of War meant that many more women were drafted in to the armed services as Queen Mary's Army Auxiliary Corps (QMAAC) where they would take on jobs in the offices, canteens and stores. This would free up the male soldiers for front line duties. One Warrington woman, May Westwell, paid the ultimate price for her war work in October 1918 becoming the town's only female fatality on active service when she was killed on *RMS Leinster* which was torpedoed and sunk by a German submarine on route from Dublin to England in October 1918. She had been the assistant administrator at Queen Mary's Army Auxiliary corps, a residential hostel in Dublin and was making a surprise visit back to her home in Lovely Lane as colleagues from the hospital explained in a letter to the family.

Your daughter got a few days' leave from me on purpose to run over and see you. She didn't even write to you to say she was coming as she wanted to give you a surprise. Your daughter was a fine officer and was respected and loved by all her fellow officers in the QMAAC … We heard from one of the officers on board … that she stood out among all the others for discipline and control, and we all feel that she died a real soldier's death … She has given her life just as truly as any soldier.

The German navy's submarine offensive against Allied shipping had been intensified from 1917, especially after America's entry into the war in an attempt to sever vital supply lines and starve countries like Britain into surrender. The Allies organised escort ships to protect the supply convoys but as Signalman Harry Boyle's discovered convoy duty could be hazardous. *The Warrington Guardian* described his ordeal when he was serving on the French cruiser *Dupetit Thouars* which was sunk by a U-boat on 7 August 1918 while co-operating with the American Navy in the protection of shipping in the Atlantic.

I had been to America on convoy duty and as I can speak French I was transferred to the *Dupetit Thouars* ... as a signalman – interpreter. We had been fourteen days

at sea when just as it was growing dusk on 7 August our ship was struck by two torpedoes-one in the engine room and one aft. There were very few boats and the majority of the crew, including myself, had to take to the water. After swimming about for a while with the aid of a life-belt, I managed to clamber onto a raft on which six men had already taken refuge. Later we pulled three others aboard. Just then the submarine came alongside and demanded certain information. He afterwards asked sarcastically asked us if we were comfortable and wished us Good-night.

The submarine then disappeared and we had nothing else to do but sit on the raft for 46 hours. Our plight can readily be imagined. We had, of course, no food whatever. As for clothing, I myself was wearing some cotton overalls, a torn singlet and a torn jumper, and had nothing on my feet. We were 400 miles from the nearest land. At the end of what seemed a very long time, I was taken on board a life-boat which had come to our aid. The following evening two American destroyers appeared on the scene and picked up the whole of the survivors. The crew of the destroyer on which I found myself gladly shared their food with us and made us as comfortable as possible in the circumstances. Four times that destroyer was attacked by the enemy, but unavailingly. After a voyage of three days and three nights I arrived at a French port where I was supplied with a khaki greatcoat and cap.

That wasn't the end of his adventures as the same night he arrived at a French town there was a German air raid and he had to spend some time in a trench. He again escaped unhurt and in due course sailed back to England where he was allowed to go home for a few days leave.

Britain's new Army Air Force which became known as the Royal Air Force (RAF) was also suffering increased casualties including Sergeant Stephen Bernard Percival, the nineteen year old son of the Rector of St Peter's Church Warrington who was killed on 14 August, shortly after being awarded the Croix de Guerre. The *Warrington Guardian* published Major Douglas Hill's letter to his parents explaining the tragic accident.

He was returning from a bombing raid and had just crossed to our side of the lines when the machine in which he was flying was run into by another machine of our formation. Both machines fell, and the two pilots and two observers were instantly killed. Your son was one of our very best airmen, and had won the admiration and respect of all ranks in this squadron ... he and his pilot, Lt Dickson, with whom he always flew, were, I may say, our most gallant and fearless pair, and that they should have survived so many gallant deeds and met their end in an accident, which was no fault of their own, is indeed, heart breaking. Your son was laid to rest in the little cemetery at a village near —, and I and several of the squadron were present to pay our last respects to those we loved so well.

Tragic though the incident was, Percival's parents at least had the consolation of knowing their son's fate. For relatives of those killed in action there was the finality of an official letter and possibly a parcel containing the dead man's effects as George

Whitfield's father would discover. L/Cpl G.A Whitfield was killed in action on Sunday May 26 during a bombardment when a piece of shell struck him in the back of his head, killing him instantly. His father received George's possessions on 28 August which were listed as, 'Wallet/Letters/photos, religious book (bible),extract from corporation proceedings, cards (various), belt and purses, gold ring (9 carat) with 3 stones, 3 coins, 2 calendars, fountain pen, wrist watch strap and protector, cigarette holder, silver disc and strap.'

Many Warrington families merely learned that their loved one was 'missing in action' and had an anxious wait to learn if the soldier would be indentified as a Prisoner of War (POW.) Although it would be many months before the ordeals suffered by Warrington servicemen in the prison camps were known there was at least the hope that the prisoner would return home once the war ended.

CHAPTER 6

KEEPING THE HOME FIRES BURNING

While many Warringtonians were away fighting in the armed forces those left behind also had a vital role to play on the so-called Home Front. As the war progressed working class housewives often had to combine managing the household without the support of the breadwinner with a new role in Warrington's war factories producing vital war supplies. There was also a role for the wives of wealthier business men in serving on the committees of local charities and many of their husbands who were too old for military service also regarded this as a worthwhile contribution to the war effort. The town formed a support network for casualties of the war – from refugees to injured service men and prisoners of war.

The first cause Warrington took to its heart was the plight of the Belgian Refugees. Propaganda in the local newspapers had stressed that the German invasion of Belgium was the justification for Britain's entry into the war. Soon newspapers

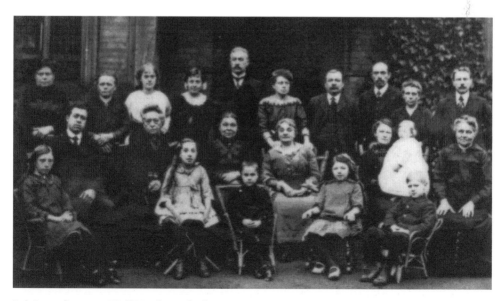

Belgian refugees at Hall Nook, Penketh.

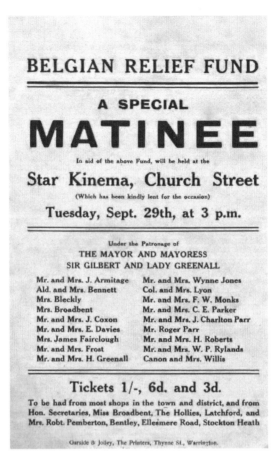

carried stories of the terrible impact of the German invasion on the lives of ordinary Belgians. In October 1914 the *Warrington Guardian* reported on the town's reaction to a party of Belgian refugees in the town as part of the national effort to support her ally.

An incident which made a strong appeal to the imagination as well as to the sympathy of the townspeople was the arrival in Warrington on Wednesday 14 October 1914 of the first batch of Belgian refugees to which the borough afforded hospitality during the war. The little band was made up of six men, three women and seven children. Two of the men had served in the Belgian Army, one having taken part in the whole of the grim fighting from Liege to Antwerp. The hastiness of the flight of the exiles was evident from the fact that when they reached Warrington the women were still without hats and wore shawls over their heads. Two of them carried babies, while tiny toddlers tugged at the skirts of another. A few small bundles and parcels contained practically all that remained of the worldly possessions of the party, though singularly enough, two of the men had brought with them their bicycles – lightly built machines which had been taken

to pieces to enable them to be carried so many miles. After a civic reception at the Town Hall, the refugees settled down in St Austin's, Bold Street, which was to be their home for many months.

This group represented the first of several contingents of Belgians who found shelter and a friendly welcome in Warrington in the course of the war. In total about 300 refugees found a temporary home in the town and at one time there were as many as ten homes under the supervision of the local committee. Hall Nook at Penketh became one of these refuges thanks to the support of the Garnett family. On 16 January 1915 the *Warrington Examiner* reported on the community they had quickly established there by interviewing one of the English-speaking refugees.

Myself and my compatriots homed here mostly come from Malines, one of the many Belgian towns which are now, in a large measure, nothing but heaps of stones and ashes. We arrived in England at the end of September and after spending some time at what might be considered clearing or sorting houses, first near London and then at Liverpool, a resting place was found for us in Hall Nook, Penketh, and it has proved a real haven of rest.

There are twenty three Belgians sheltered under this roof. The work of the house was arranged on a systematic plan. To the women naturally fell the housework, the washing, cooking, cleaning etc. The men in addition to assisting in the rougher housework, help in the outdoor work of the estate. Anticipating that our stay might be long we have started pig rearing.

The Belgians were also trying to integrate into the community by giving French language lessons to about 30 students from the neighbourhood while the Belgians were learning English. However, they were finding exiled life difficult despite the kindness shown by their English hosts.

One of the first tests of Warrington's determination to maintain normal life came at Christmas 1914. Many had been convinced that Britain's war would have been over in a matter of months and now they were faced with the reality of the first traditional occasion for celebration without many of their loved ones. It was especially hard for families with young children but the town did its best to try to maintain a semblance of normality and even the weather played its part as the *Warrington Examiner* reported.

Christmastide was observed locally in a way at once becoming and dignified. Soldiers of the king, home for a short holiday, were to be seen in plenty, their dress and their smart bearing lending a realistic touch to the kind of life to which we are now becoming accustomed. In which we have such constant reminders that we are engaged in a life and death war.

'Business as usual' has been the motto and the shopkeepers have had a busy time. The wounded soldiers in our midst were also given a comparatively good time. There was a touch of the old fashioned Christmas in the weather for on Friday morning the earth wore a becoming mantle of hoar frost. In the morning under such ideal

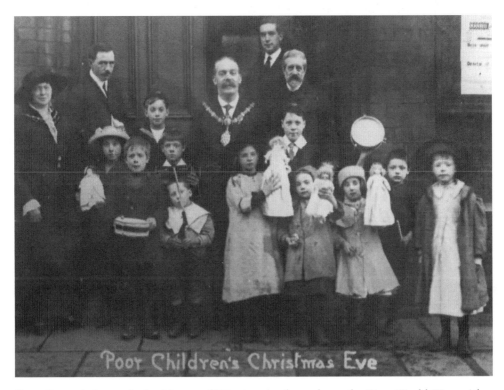

Peter Peacock (centre), the Mayor of Warrington throughout the First World War, with a Christmas treat for poor children.

Christmas conditions, and with such a picturesque setting, large numbers of people journeyed to the places of worship.

A year later there was still no end in sight to the fighting and the *Warrington Guardian* took a more reflective note,

We celebrate Xmas this year (1915) to the roar of distant artillery. There is something ironical and humiliating in the thought that after so many centuries of Christianity, we still resort to barbarous methods of slaughtering each other, in order to settle our differences. The propriety of talking about, *Peace on Earth and Goodwill Towards Men*, at this period has been called into question ... Our rejoicing will of necessity be chastened, but the note of gladness need not altogether be lacking. We shall think of the absent ones with pride and gratitude and in our innermost hearts pray for the dawn of a peace that will be beneficial and lasting. There are dark days ahead; days when we shall learn of our dearest and best being taken from us, but we shall not flinch. The path may be hard but we shall tread it undaunted to the end.

Early 1915 brought new challenges for the people of Warrington when they were warned to expect that the war might come directly to the town with the growing threat

of German bombing raids over Britain from airships known as zeppelins. The papers were full of stories of their deadly effect and on 12 February 1915 the local press gave the people of Warrington notice of how the town should prepare for an attack. A general warning would be given by the sounding of a one minute blast from Crosfields' factory buzzer, followed by an interval of 30 seconds, and another minute blast while a further indication would be the reduction of the electric current. To familiarise everyone with the procedure Crosfield's buzzer would be sounded 'on Saturday next at twelve o'clock noon'. A blackout regime was also introduced by the Lighting Order which applied during the night hours to prevent zeppelins seeing targets. The munitions works were exempt as long as this would not endanger their work force.

The *Warrington Guardian* warned that,

From Wednesday next week Warrington will assume a very sombre aspect. On that day the lights will have to be reduced to the lowest possible limit. In some buildings … the skylights have been painted a bluish colour. This is of course a great inconvenience during the daytime, and necessitates additional expenditure in the shape of electric light and gas illumination. In the case of the shopkeeper or householder green or dark blinds or curtains can be serviceably introduced, or for those that cannot afford the cost, an excellent and cheap substitute is brown paper. There has been a considerable reduction in the lighting of the streets. The tops of the lights have been painted black while some of the electric lamps have been painted a rather effective sky blue.

Fortunately Warrington was spared the zeppelin raids but it was yet another daily reminder that the town was at war. For Warrington women the reality of 'Keeping the Home Fires Burning' was becoming ever more challenging especially as they were now expected not only to run the household but also contribute to the war effort. At a British Red Cross Meeting in 1915 one speaker asserted that, 'The men could not go to the front if the women did not come forward and qualify themselves to carry on the work of the country.'

While some Warrington women did fulfil the stereotypes of newly empowered women with careers the majority still had to raise children and keep the home running. For working class women family life was hard. Many lived in cramped, damp, vermin infested houses without electricity and appliances such as washing machines, dish washers, microwaves and vacuum cleaners which make combining a job and family life possible today. Few homes in the older districts of the town had running water so it had to be carried a distance from the communal pump and then heated in a coal fired boiler for wash day or in a kettle boiled on the grate for bath night in a tin bath in front of the kitchen fire.

Women whose husbands were on military service received a separation allowance which included childcare allowance so some working class women actually found the family income increased if their husbands had been in irregular or poorly paid employment before the war. If there were several older children in the family they could also contribute to the family income since the shortage of manpower meant that there were good employment opportunities.

The women left behind as their menfolk go off to war in 1915.

These allowances were also paid to common law wives although many self appointed guardians of public morality were shocked at the number of women who were co-habiting and felt that they were more likely to fritter the allowances away on drink. The state and various charitable organisations felt that it was their duty to monitor mothers' habits. As deaths mounted on the battlefield babies were seen as precious commodities which represented the nation's future. It was perceived that such 'feckless' mothers would endanger this unless they were taught good childcare and given nutritional advice, especially as food became scarcer.

Society also struggled with the idea that women would frequent pubs and cinemas especially if their men-folk were absent on military service. Local newspapers featured articles by self-appointed guardians of the factory girl's morality condemning their lax drinking habits or accusing them of falling victim to 'khaki fever' by fraternising with troops home on leave or convalescing in local hospitals. On 13 January 1917 the *Warrington Guardian* reported an offence under the Defence of the Realm Act which prohibited supplying drink to wounded soldiers. Two women from Lower Ship Yard, off Bridge Street, were jailed for getting a gallon of beer each, taking it home and drinking all evening with two Canadian soldiers from the Lord Derby Hospital at

Winwick. The police felt that the main breach of the law had not been by the landlord who supplied the drink but by the women who had bought it.

Lillian Evans, the Welfare Superintendant of the St Helens Cable and Rubber Co. Ltd Warrington provided guidance on moral issues for the new female workforce. She referred to more delicate issues, such as being prepared against sexually transmitted infections, described as 'certain personal diseases' where the infected person would previously have been judged to have engaged in immoral conduct. Her advice was firm,

> Do not let yourself be persuaded in order to keep your spirits up that it is desirable to go to a place of entertainment every night. Maintain your womanly dignity always. Be true to your sex. It may be fun to *pick up* for a time, but the after effects are, all too often, very bitter and sad.

Concern about Warrington women's morals was also expressed in the local press in April 1917 but the Medical Officer of Health pointed out that the illegitimate birth rate in Warrington was no worse than in many other neighbouring towns.

By 1917 Warrington was beginning to feel the effects of the national shortage food shortage and there were more demands on women to avoid food wastage by

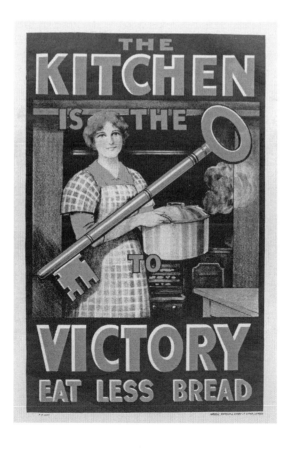

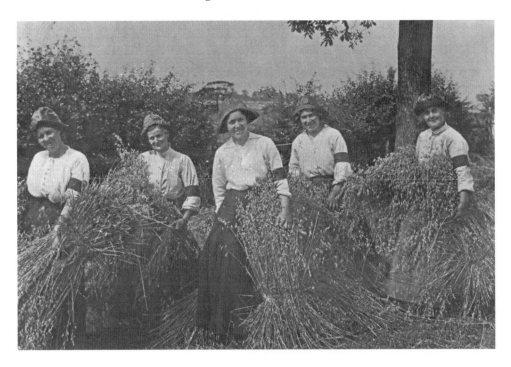

Above: Land Army women at Hatton.

Right: Molly Meadowcroft's life changed forever when she came with the Land Army to a farm at Winwick. There she met her future husband Arthur Jackson who was convalescing at the Lord Derby War hospital.

careful planning of the family's diet. Increases in munitions production had affected the amount of food grown in the country because nitrogen and phosphates were diverted away from their previous use in agricultural fertilisers. By February Britain's food supply was also under strain as Germany resumed submarine warfare attacking shipping to Britain which imported about two thirds of its food supply. Meat and sugar were sunk en route leading to the introduction of the convoy system. It was also clear there would be a shortage of male workers to bring in the crucial harvest at home that year and German prisoners of war were drafted in to work the land.

In January 1917 a new Women's Land Army (WLA) had been mobilised to help improve productivity on the land and ease the shortage of agricultural labour. The intention was that they would carry out unskilled agricultural work but many farmers were reluctant to take them on. Few working class women volunteered for the force as they realised they would be better paid in the factories since agricultural work meant long hours, poor pay and poor accommodation. By June 1918 nearly 30,000 women were needed on the farms around Warrington and neighbouring Cheshire villages. They would be treated as unskilled casual workers and paid five old pence (about two new pence) an hour for their often back-breaking work. In reality only a small number of WLA members assisted with the 1918 harvest with the majority of the women working on the land coming from traditional farming families.

Warrington families were encouraged to grow their own vegetables by an increase in the number of allotments available. There were plans to use part of the newly acquired Orford Hall estate, part of Victoria Park, two to three acres of land in Oakwood Avenue and part of the site acquired for a school and recreation ground in Lovely Lane. The sixteenth of an acre plots were to be used for growing vegetables as flowers were regarded as a luxury in wartime.

The local newspapers also reported prosecutions of those who were considered to have wasted food or tried to hoard it illegally. Imported sugar was rationed and several local women were prosecuted for their jam making activities as they were not using fruit they had grown themselves (which was legal) but instead using shop-bought fruit. Even a local ice-cream maker was prosecuted for allegedly hoarding sugar.

Farmers were also feeling the effect of horses being taken for military use which affected their ability to undertake such essential farming tasks as ploughing the land and harvesting the crops. Sir Gilbert Greenall used his expertise in stock breeding of horses, pigs & cattle for the national benefit during the war years. *The Warrington Guardian* later described his contribution:

The tremendous value of his profound knowledge of horses was proved to the world during the war, when he was appointed by the President of the Board of Agriculture and Fisheries as a member of the committee on the Supply of Horses for Military purposes for England and Wales … He was chairman of the Live Stock Committee for the Relief of Allies Fund, inaugurated by the Royal Agricultural Society of England, which fund reached nearly £200,000 (approximately £8–9 million in today's values.)

Live stock shipments were frequently made for relief in the devastated areas of France, Belgium and Serbia up to the value of £150,000. During the war he took an active interest in all matters connected to the Board of Trade, the Board of Agriculture, the Ministry of Food and other Government Departments. He was also chairman of the committee which dealt with the demobilisation of Army horses ... As member of the Horses and Livestock Advisory Committee, he did work that probably no one else in the country was so fitted to do.

Sir Gilbert Greenall was also a leading figure in Warrington's network of voluntary workers. The wives of key local politicians and industrialists found a new role in organising the town's essential voluntary work of charitable events and supporting government fundraising drives to supply more ships and aeroplanes. In March 1918 the town had been asked to raise £150,000 to pay for a destroyer for the navy but actually raised £342,467.

Lady Frances Greenall had already worked tirelessly on the Front Line by running the Walton Hut. On her return to Warrington she set up the Blighty Club to provide a similar outlet for service men home on leave and convalescing. She had always been a formidable political campaigner for the Conservative party behind the scenes and she used these skills and her female circle to help organise collections of warm clothing to send out to the men overseas.

Sir Gilbert and Lady Greenall (*seen on the left of this photograph*) with Harold Smith, the town's MP.

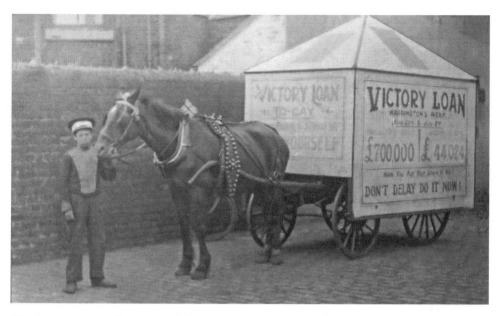

Warrington generously supported the government's campaign for Victory Loans in 1917.

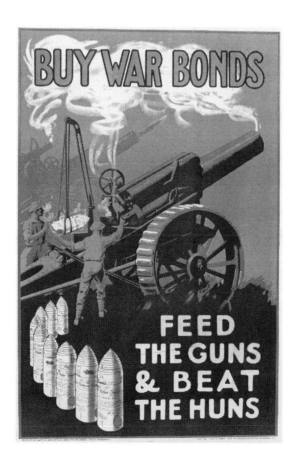

The Blighty Club was set up in the Conservative Club in Sankey Street and an army of entertainers recruited, including music hall celebrity George Formby (Snr).

Public appeals to fund the work of the Red Cross and supply comforts to the men on active service and their dependents at home were always generously supported by the people of Warrington. The *Warrington Guardian* described the relief operations which took place at the Parr Hall – which virtually became the Local War office: 'There is no fuss and surprisingly little red tape. The work of the Soldiers' and Sailors' Association and the Soldiers' and Sailors' Help Society is carried on and since the early days of the war valuable help and advice has been given to the dependants of local soldiers and sailors.'

As news of the hardships suffered by local prisoners of war serving in the South Lancashire Regiment reached the town the Parr Hall became the centre of operations to send food parcels and clothing to provide some comfort in their harsh prison camps. By February 1917 families were no longer able to send parcels direct to prisoners but had to send them through the South Lancashire's Regimental Care Committee whose headquarters were at the Parr Hall. Dispatching the parcels was a massive logistical operation as the *Warrington Guardian* later reported.

First of all letters began to come through to the prisoners' relatives asking for food, clothing and boots – especially boots – to be sent out to the men. These letters were

Volunteers collect books for soldiers.

taken to the Parr Hall, notes made, and eventually the necessary machinery put into operation for supplying the urgent needs of the prisoners ... The number of food parcels sent out to the men of the South Lancashire Regiment to a recent date was 9,024, the weight of the materials being about 35 tons. In addition over 10 tons of clothing and boots were supplied during the winter of 1915-16 and a similar quantity is being prepared for this winter.

The weekly cost of sending out the parcels was also raised locally but sadly the efforts of the local volunteers were sometimes in vain for when the POWs returned at the end of the war they reported that many of the parcels had failed to reach the prisoners.

By November 1917 the Warrington District Local Pensions Committee was also meeting regularly on the first Wednesday of each month at the Parr Hall. They were involved in cases such as the care of motherless children, either while the father was on active service or on his death. They also looked into the cases of increasing numbers of disabled soldiers who had been discharged as unfit for duty and needed to find light employment to survive. By early 1918 it became clear that the town's military hospitals were no longer able to provide care for disabled or discharged men and the town's support for the voluntary groups caring for injured soldiers became even more vital.

HAROLD THOMSON

(age 21), prior to enlistment, was an employee of Messrs. Joseph Crosfield & Sons, Ltd., of Bank Quay Works, Warrington.

H. Thomson at his bench at St. Dunstan's.

A poster appeal for St Dunstan's to support local blinded ex-servicemen.

CHAPTER 7

WARRINGTON'S WAR HOSPITALS

Servicemen who were more seriously wounded and needing hospital care were usually sent back to Britain after immediate treatment at the Front. Soldiers often welcomed a wound that was serious enough to get them sent home from the hell of the trenches, referring to their injury as 'getting a Blighty one'. Many were sent to nursing homes for convalescence before returning to action or being discharged as no longer fit for active service.

During the First World War Warrington and the immediate neighbourhood had a number of hospitals caring for the less seriously injured including:Raddon Court Hospital Latchford and its annexe at Stockton Heath; Orford Barracks Hospital; the Whitecross Military Hospital; the Warrington Infirmary; Thelwall Heys Military

A drawing of Raddon Court Hospital by a patient.

Convalescent Home; and the Oaklands, Preston Brook. Many more seriously injured cases found themselves at the Lord Derby War Hospital which had taken over the Winwick asylum and was one of the largest military hospitals in the country.

Raddon Court was a large house on Knutsford Road Latchford which the Greenall family loaned to the Cheshire Division of the British Red Cross in August 1914 to provide a war hospital. The British Red Cross had to raise funds for the venture so various local dignitaries were involved including Lady Greenall and Lady Crosfield. However, it was the Broadbent sisters who effectively ran the venture. These spinster daughters of a deceased Latchford tannery owner had lost two brothers in the Boer War and seen a third incapacitated, while youngest sister, Lucy, had flirted with the suffragette movement in the years before the war.

War work provided an opportunity for their patriotism and organisational skills through the British Red Cross Society. From 1914-19 the sisters effectively operated a military hospital under the control of the war office but entirely dependent on voluntary contributions. Raddon Cross Hospital stood conveniently across the road from their family home at the Hollies whose grounds were also used for convalescing patients. As Vice President of the Daresbury Division Sylvia Broadbent worked tirelessly in a fund

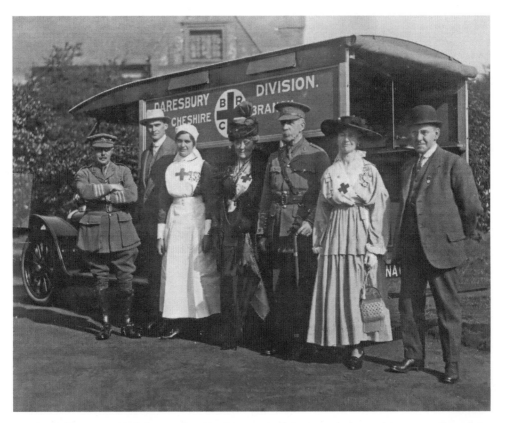

Tom Broadbent (second left) acted as a volunteer Red Cross ambulance driver even though he was too ill to rejoin his regiment.

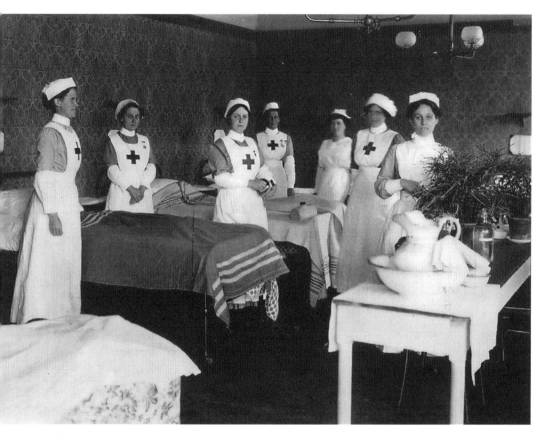

A Raddon Court Ward ready for inspection.

raising role while her younger sister Margaret was hospital Commandant as head of Cheshire No.22 Voluntary Aid Detachment.

Raddon Court opened in September 1914 with beds for thirty two invalids and admitted twenty five wounded Belgian soldiers at the opening on 19 October 1914 but a year later there were 48 patients. The hospital was staffed by Margaret Broadbent as the commandant; Madge Evans as the lady superintendant; three trained nurses, eight Red Cross nurses plus Red Cross volunteers, cooks, waitresses and ward maids. There were also two doctors in attendance including Dr Edward Fox who issued a report on the running of the hospital in July 1917.

I am much impressed with the thorough way in which the work is performed ... and the patients have made excellent progress ... Apart from the surgical treatment, a systematic effort has been made to provide mental treatment, by employment in the grounds and gardens, handicrafts, and entertainments; these methods have had a markedly beneficial effect in improving the mental out-look of the patients. The discipline has been well maintained, and no serious breach of the rules has been tolerated. Marching and exercises for all the patients not confined to bed have

been regularly carried out by the non commissioned officers, and this has proved a valuable means for gradually retraining the men for the resumption of duty ... The general management of the hospital ... has been most effectively carried out by the Commandant.

By the time of its closure in May 1919, Raddon Court had tended over 1,600 patients from a variety of nationalities but the military hospital at Orford Barracks had treated almost ten times as many. Based at the Warrington headquarters of the South Lancashire Regiment this hospital had opened at the commencement of the war on 4 August 1914 with one ward of thirteen beds. This had gradually increased to a maximum of 81 beds under the supervision of Acting Matron Mary Gornall who was assisted by Red Cross nurses and military orderlies. Almost 100,000 patients were treated at Orford Barracks although most were outpatients. Mary Gornall reported that,

> Every imaginable kind of case had passed through the Hospital; the wounded, gassed, those suffering from frost-bite, shell-shock, neurasthenia, malaria, consumption, and all manner of skin diseases. Fifteen hundred repatriated soldiers passed through the hospital for medical examination, or for treatment, and there were a long list of limbless patients who attended the hospital regularly for medical inspections.

The hospital also treated the military victims of the two devastating influenza epidemics which raged in 1918.

Patients display their craft work at a Raddon Court fundraising day.

The military authorities also took over two wards from Warrington Workhouse to help operate the Whitecross military hospital where, as the *Warrington Guardian* reported on 27 January 1917, 'The lady doctor has made her appearance in Warrington. Dr Mary Anderson Noble has been appointed resident house surgeon at the Whitecross Military hospital.' However, Orford Barracks and the Whitecross facility soon proved inadequate to cope with the growing number of military casualties which included Allied troops as well as British. It soon became clear to the military authorities that more specialised care was needed to cope with a growing number of soldiers who were exhibiting signs of mental illness from their experiences in trench warfare as well as dealing with the increasing number of surgical cases.

Those serving on the Western Front experienced a new kind of warfare; sustained bombardment from heavy artillery in the narrow confines of the trenches which left many soldiers exhibiting signs of what was eventually recognised as shell shock. With the shortage of man power many received scant sympathy when they were unable to perform their duties and were often described as shirkers or shot as deserters if they did not return to their post. There was a growing perception that officers received more favourable treatment as they were allowed to return home and be admitted to a private hospital to recover. Working class men displaying the same symptoms who were sent back to Britain were more likely to be admitted to the local 'lunatic asylum' with the resulting stigma for their families who justifiably felt that their loved ones problems had been caused by the war and the army should care for them in a more appropriate way.

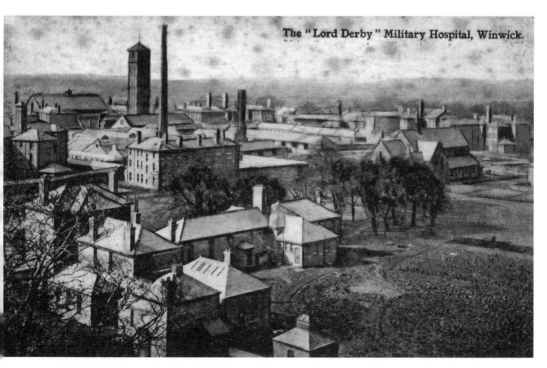

Postcard view of the Lord Derby Military Hospital.

There was no obvious provision in military war hospitals for service men suffering from mental or nervous breakdowns and in 1915 the Army Council requested at least 50,000 extra beds for war casualties with mental issues from the Board of Control which presided over all county and lunatic asylums in England and Wales. Selected existing 'county lunatic asylums' were to be turned into War Mental Hospitals for all ranks of men but they were to be described as Military Hospitals rather than asylums.

On 27 February 1915 the *Warrington Guardian* reported that Winwick Asylum was to provide accommodation for 4,000 soldiers and that 2,200 of its existing patients would be transferred to other asylums. Winwick Asylum was taken over and renamed the Lord Derby War Hospital. It became the largest military hospital in the country with over 3,000 beds. Between 1915 and 1920 over 56,000 soldiers were treated there including some patients who received electric shock treatment rather than therapy for their condition. About a third of the beds were used for treating patients with what were classed as 'mental disorders' and the authorities agreed that all such patients who did not recover should be retained in military hospitals until after the war.

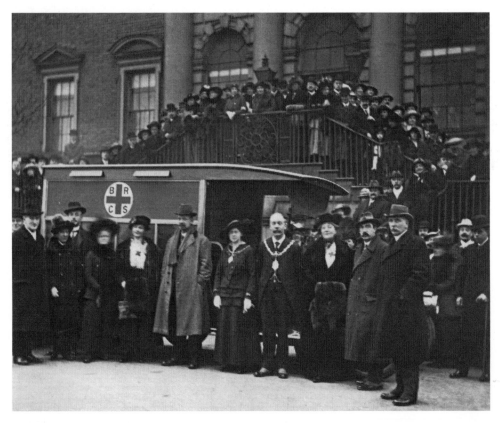

In February 1917 the Warrington Freemasons presented an ambulance to the Red Cross Society to be used to ferry wounded soldiers from local railway stations to the Lord Derby Hospital at Winwick.

One of the Lord Derby War Hospital's main tasks was to ensure that as many patients as possible could be made fit for active service and it adopted a tough regime for those classed as having metal disorders. The hospital attracted national notoriety for the treatment of two high-profile cases. The first concerned Emanuel Ribeiro a conscientious objector from Salford who had gone on hunger strike when his appeal against conscription on religious grounds was rejected. He was transferred to the Lord Derby Hospital where he was force fed through a tube in the same method previously used on suffragettes. The intention was to make his treatment so unpleasant that he would give up and accept conscription However, Ribeiro held out for fourteen months although his health was deteriorating. His case was taken up in the regional press and questions raised in the House of Commons. He was eventually court-martialled and sentenced to two years hard labour but released on the grounds of ill-health.

In 1918 the poet and composer Ivor Gurney was transferred to the Lord Derby War Hospital after showing signs of mental disturbance and delusions at Newcastle General Hospital where he was being treated for war wounds and the effects of a gas attack. Gurney had enlisted in 1915 and fought in some of the bloodiest battles at Ypres, the Somme and Passchendaele. When he was repatriated to Britain for treatment he discovered his father's health was failing; he began to doubt his own talents as a writer and poet and his girlfriend broke off their relationship because she could not

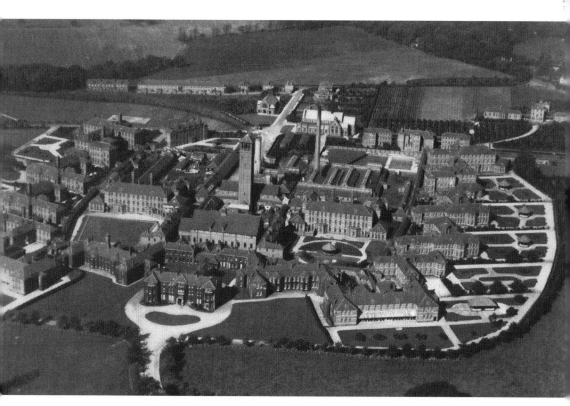

An aerial view of the Winwick County Asylum site.

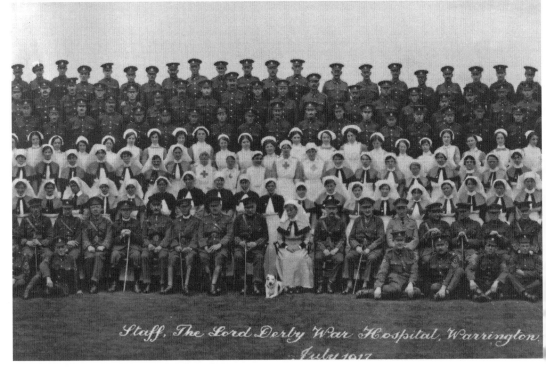

Staff, The Lord Derby War Hospital, Warrington. July 1917

Staff and patients at the Lord Derby War Hospital at the former Winwick Asylum.

cope with his depression. It was perhaps not surprising he was later diagnosed with 'a nervous breakdown and deferred shellshock'.

The confined existence at Winwick made Gurney suicidal and he threatened to drown himself, writing to his friend Sir Hubert Parry he said, 'I know you would rather have me dead than mad.' His friends alerted the authorities who prevented his suicide but it was clear that the Lord Derby War Hospital was not the right environment for Gurney. A friend who visited him before he was transferred to a less austere regime said that the Lord Derby War Hospital was 'the most detestable place I have ever spent six hours in without exception and the place would drive me mad, despite my lack of genius, in a very few weeks.'

A member of the board of the Lancashire Asylum Board was more generous in his assessment of the hospital declaring, 'You now have a thousand men occupying beds in the west wards who are suffering from mental trouble, but not one of these I am proud to say, has been branded insane.' The hospital remained open until 1921 when Winwick resumed its former role as the county asylum. By then the war was over but many former service men would be affected for the rest of their lives by the physical injuries and mental scars they received from their experiences in the First World War.

CHAPTER 8

PEACE AT LAST

By the autumn of 1918 it seemed as if Britain and the Allies were at last winning ground against Germany and her allies and there were signs that the people of Germany were also war-weary. Events seemed to move swiftly as John Paul Rylands recorded in his diary in October and early November 1918. On the first of October he noted that, 'The Bulgarians have surrendered to the Entente powers. We are victorious everywhere and now we seem to have really reached the beginning of the end of the war.' By 19 October he learned that there was, 'excellent war news; more successes on the Belgian coast and in France. The Huns are beginning to realise their danger and America is determined to exact punishment and reparation for their horrible crimes. The accounts just published of their treatment of prisoners are terrible; many were actually starved to death.' By 7 November he began to feel that events were moving to a conclusion in Germany as, 'The German Empire is going to pieces; they have just sent a flag of truce to Marshal Foch and there are serious riots in Hamburg and at Kiel the revolutionaries have seized a number of the war ships and hoisted the red flag.' Two days later he wrote, 'The Crown Prince disappears with the Kaiser and a meeting was held in Berlin at which it was arranged to appoint a regent and to give the country constitutional government.'

Rylands' optimism proved correct for that very day Kaiser Wilhelm abdicated and went into exile paving the way for peace negotiations. Germany signed an *armistice* or truce with the Allies on the eleventh hour of the eleventh day of the eleventh month. However, the war was not officially over until the formal peace treaty was signed at Versailles in June 1919.

Amid the rejoicing many Warrington families also remembered those who had been killed or whose lives had been changed for ever by the events of the last four years. Many widows, fatherless families and injured veterans would need support and so the women of Cockhedge Mill decided to take action as one young girl would later remember.

After the workers had decorated the Mill the public were asked to go along to view the factory. My mother took my younger sister and me along. We left the house in our red, blue and white trimmed hats and with red, blue and white ribbons in our hair. The queue stretched from the factory gates to the end of Orford Street and round into Crown

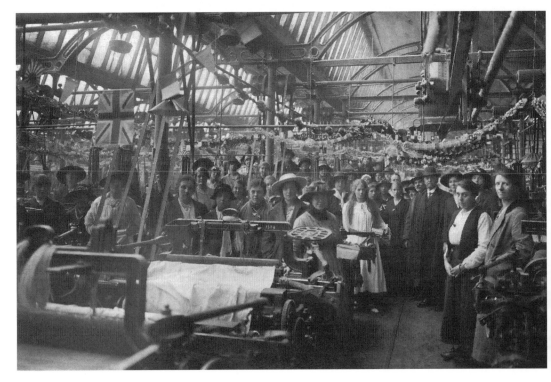

Cockhedge Mill decorated for Armistice Day 1918.

Street where we joined it. When we neared the gates Mam gave my sister and I a silver threepenny bit to give to the voluntary collection. Mam gave sixpence, known as a tanner. In all we three gave a shilling, and in those days a shilling was small fortune. Anyway, we were all taken round the Mill. It was beautifully decorated and the weaving sheds were absolutely fantastic. The only colours were red, white and blue. How wonderful it looked.

After the prolonged strain and anxiety of war Warrington abandoned itself to rejoicing on Armistice Day as the *Warrington Guardian* recorded in the detail this momentous occasion demanded.

In Warrington as in every city, town and village in the country, Monday was a never-to-be-forgotten day. The news that the last shot had been fired in the war which had convulsed the world for over four years was received with profound relief, and as the day wore on gave rise to scenes of indescribable enthusiasm …

The day dawned with expectancy in the air. It was with difficulty that anyone could settle down to the 'daily round …' It was not until 11.20 that the official news was given to the town and the public learned not only that the fateful document had been signed at 5 a.m. but that hostilities had actually ceased at 11 o'clock. The first public signal that the glad tidings had been received was the sounding for several minutes of Crosfields' hooter,-the hooter whose weird noise one recalled with some emotion

had summoned our Territorials to headquarters at the beginning of the war; the hooter which had also served to warn the neighbourhood when the Zeppelin menace assumed definite shape … In a short time the other works buzzers joined in strident chorus and detonators were also discharged.

The effect in the streets was almost magical … now they were filled with excited people who almost breathlessly asked each other, 'Can it be true?'… There was an immediate cessation of work; everywhere one saw the victory smile and chance acquaintances shook hands with brotherly warmth. Flags and streamers which had been kept in readiness for this day of days now made their appearance giving the town a festival aspect … Church bells too rang out in joyous peals; children rushed happily from school with the knowledge that a holiday was assured … And an ideal day it was for celebrations. The weather was fully in keeping with the all-pervading happiness for there was mellow autumn, and an atmosphere of serenity and peace … Overwhelming gratitude for a great deliverance was mingled with a feeling of pity for those who by the general happiness would be reminded of loved ones who would never return.

The Town Hall became the focus for celebrations as it had been the scene of so many important occasions during the war. The Mayor, Sir Peter Peacock, formally announced the completion of the Armistice and paid fitting tribute to the valour of Warrington's sons in the fighting Forces. The *Warrington Guardian* was quick to include a mention of Lady Greenall describing her 'stirring speech [which] spoke of all that our victory meant to mankind and of our inestimable debt to the gallant dead.' During the rest of the day

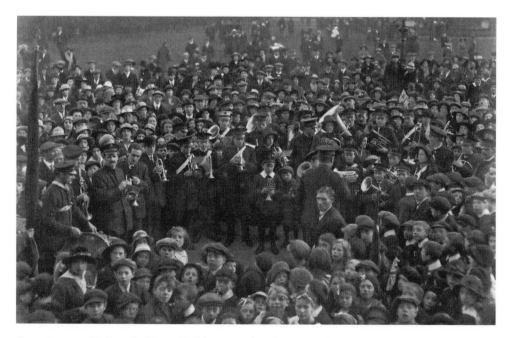

Crowds assembled on the Town Hall lawn on the afternoon of Armistice Day with the Salvation Army Band.

there were thanksgiving services and the rejoicings culminated in a torchlight procession through streets which were filled with sounds of revelry until late in the night.

Now was the time for the local press to reflect on Warrington's part in the great events of the previous four years. The *Warrington Guardian* proudly declared that,

> Our ancient town had a great name to uphold; never in the hour of stress and danger had it been found wanting ... Its achievements in every branch of war activity will ... bear favourable comparison to those of any town of similar size and population. The vital and dominant demands upon the community were crystallised in the three M's – Men, Money and Munitions. Under each head Warrington rose to a full sense of its responsibilities. The call *Your King and Country Need You*, evoked an immediate and magnificent response from the young manhood of every walk of life; later the town played a worthy part in supporting the financial offensives by a steady supply of *silver bullets*; while throughout the war the whole of the industrial resources of the borough were concentrated upon the production of munitions and other necessaries of war.

Life began to return to normality for the inhabitants of the town and many families were able to welcome home a steady stream of Prisoners of War by late December. Most of the men, even those badly wounded, had to walk as best they could to the Dutch frontier, where they were able to get travelling accommodation to Copenhagen. Here they boarded Danish steamers specially chartered by the British Government and within the same day had landed in Hull.

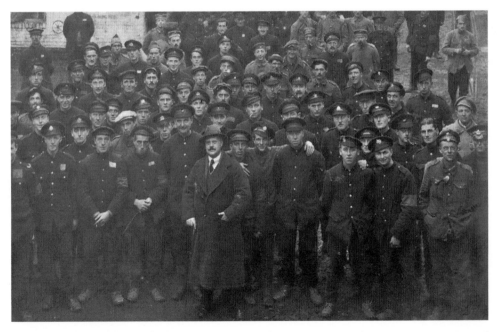

British Prisoners of War including Sidney Upton (first left on second row) at Soignies Forced Labour Camp in Belgium, October 1918.

Naturally the local press were keen to interview them about their experiences. Many of the returning POWs had graphic stories of their experiences in the crowded prison (or concentration) camps. Ill treatment by the guards, lack of food, water and basic hygiene were common themes and made forced labour, often behind German lines, harder to endure. Despite the efforts of Warrington volunteers many carefully packed British Red Cross parcels failed to find their way to some of the camps. The *Warrington Guardian* noted that,

> The hardships and privations they have suffered fade in the re-union with their wives and families, and in spite of everything there is not a dull face among them ... One finds the repatriated soldier reluctant to discuss his experiences whilst in the hands of the enemy. Too many have been the victims or witnesses of the most brutal treatment. On the other hand some men say they had received not unkindly treatment but these cases are few and far between. All have, however, the same cold contempt for the Hun.

Rifleman Thomas Fogg of the 1st Battalion Rifle Brigade of No. 62 Battersby Lane was one of the town's earliest POWs being captured on 26 August 1914 at Mons. He told of the horrors of internment in a prison camp and ill treatment by the German guards who had been told that the British had taken the eyes out of wounded German soldiers with jack knives and violated the white flag. They were herded on to cattle trucks for a journey of three days and three nights and 'when we begged for water they invariably asked if we were Englishmen and threw it in our faces.'

Pte J. J. Barnes of the 2nd South Lancashire Regiment was another of Warrington's longest serving POWs and was well known in the town as the manager of the Star Kinema (a cinema in Church Street.) He had been wounded and taken captive at Neuve Chapelle on 21 October 1914 and spent most of the war in the notorious Wittenburg camp. Barnes was more than willing to give a detailed account of his experiences.

> For nine months we never knew what it was to have a shirt, a piece of soap or anything to wash ourselves with, and the food was very bad. The cruelty to the prisoners was awful during the first half of our captivity. Trained dogs were set on some of the hapless men, and others were lashed with rubber tubes. Another form of torture was to compel prisoners to stand, tied to posts, in the glare of the sun for long intervals. About 900 Belgian civilians were brought to the camp, but they refused to work, and as a consequence were literally starved. They came into our quarters groping about for any scraps that might be left. After two years and six months the treatment improved somewhat. At the same time we were thankful to the people that sent us parcels; we could not have existed without them.

Pte Barnes especially thanked the Regimental Care Committee for their work in regularly ensuring the parcels were sent out to the camps.

In contrast First Class Air Mechanic William Holden of Whalley Street attributed his less harsh treatment to his ability to speak German. 'I have not been ill-treated in comparison with other men. One or two hits with a rifle in three years I count as

nothing.' He had been taken prisoner in December 1915 when on patrol in a Vickers fighting machine which was shot down by anti-aircraft fire. He was first taken to Lillle which was acting a concentration camp and later sent to Altdamm in Pomerania. As he spoke German he escaped manual work and was put to work in the camp's post office, checking the prisoner's parcels and trying to chase pilferers. He claimed that, as a rule, the parcels arrived in excellent conditions and the Germans seemed scrupulously fair in dealing with them.

Asked how the news of the Armistice had been received by the German he said that,

Both the military and the civilian population were surprised – in fact they did not believe it. They still had faith in the Kaiser. Our men in the camp took the news very quietly. The French were more impulsive and began to make flags and to shout and sing. The Englishmen, however, seemed chiefly concerned with ascertaining the full conditions. They wanted to know if the German army had been completely defeated.

Pte James Nolan's experiences in the so-called Black Hole of Lille reflect more the common brutal treatment which bordered on war crimes. He was serving in the First 5th King's Own (Royal Lancaster Regiment) when he was captured in April 1918.

I had not been long in captivity before I found out that we could never expect any mercy. A Prussian officer walked amongst us and deliberately shot every sixth man … At Lille there was a notorious prison known as Fort Macdonald … It was composed of a series of underground dungeons. Into one of these prisons with only one small window to let in light and fresh air 350 men were crowded, I, myself being one of them. The sanitary conditions were terrible … there was about fifteen inches of filth on the floor and at night time we slept on planks … For about three minutes each day we were allowed to leave this living hell to get a piece of bread and a bowl of bean broth which comprised our midday meal. When a man got into the fresh air reaction would take place and he would fall down exhausted because he had been so long kept in the dark dungeon where the air was foul … For want of water several men went mad. We were prepared to give anything for water and often tried to get it by putting a tin can through the window with a five franc note inside for the sentry if he would fill it with the precious liquid. Sometimes we were successful but more often than not the money was stolen and we got no water in exchange. Prisoners sold all their belongings for food and water and I have seen a wristlet watch given in exchange for a dirty piece of bread.

To make things worse, dysentery swept through the camp claiming many lives. The frightful strain on our nerves was one day released by our removal to a place behind the Hun lines, where we were employed in carrying shells and putting down railways. We found the work very hard as we were naturally as weak as kittens after undergoing the ordeal of those terrible three weeks. We could scarcely drag one leg after the other, but we all viewed the change as one for the better. Several men who had survived the black hole of Lille met their deaths from the Allied long range guns and air raids.

When the great British offensive started just before the signing of the Armistice we had to retire with the Germans. During the retreat we passed into the village of Braine Le Chateau, and our rather undignified entry rather surprised the inhabitants ... Imagine what we would be like if you can – clothes absolutely in rags, pinched and drawn faces, rendered unrecognisable by the natural results of not having a wash for weeks on end.

Conditions improved slightly for the prisoners as through the intervention of the Spanish Ambassador in Brussels they were given shirts, soap, needles and cotton, and more importantly two cows to be killed for food. On the eve of Armistice Day none of the prisoners went to sleep as they were too jubilant over the good news which had been leaking through. On 11 November, Pte Nolan added, the prisoners were at liberty to go where they pleased as the sentries had left the camp. As the British walked outside the gates they met some German soldiers who were passing on their way home. The Germans shouted, 'The war is finished, Tommy; the war is finished', and attempted to fraternize with them but the former prisoners would have nothing to do with them. The villagers later held a banquet to celebrate the good news and many British soldiers were among the honoured guests.

Private Harry Clarke of the 2nd South Lancashire Regiment reported similar atrocities in the 'dog kennels of Lamsdorf' where only the most strong willed survived.

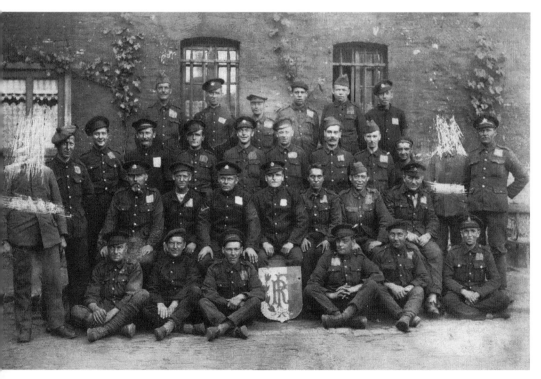

Upton scratched away the faces of his German guards on this photograph of his prison camp.

Nearly every nationality was represented in that camp ... The huts in which we had to live were partially sunk into the ground ... The mortality was very heavy, one hundred men dying per day. What survivors there were owed their lives to the fact they never lost hope. Had they done so they would have been amongst the many who were fated never to see their homes again. The British Tommy, always resourceful, made cigarettes out of the weeds growing profusely in the camp, and the comforting properties of a smoke, even in such circumstances, did much to keep his good spirits to the fore.

In many respects we were much better off when we were sent to Morgenroth ... We had to work very hard though, being employed in a fabrik or factory. Most of our clothes were taken off us, and we often sold our shirts to the Russians for food. By the time a week or so had elapsed we were wearing precious little ... For working in the fabrik we received three marks (about three shillings) a week, and if we were good we got five cigarettes. Usually we never got the cigarettes. When we had a minute to spare we would sit around a table talking about the far-off times we had in dear old *Blighty*.

In spite of the fact that the Armistice was signed on November 11th, the camp authorities tried to make us work until November 30th. Naturally we flatly refused and downed tools. The guards were brought out to us, but it was no use. We would not work anymore. We were filled with dread when we were told we were going back to the

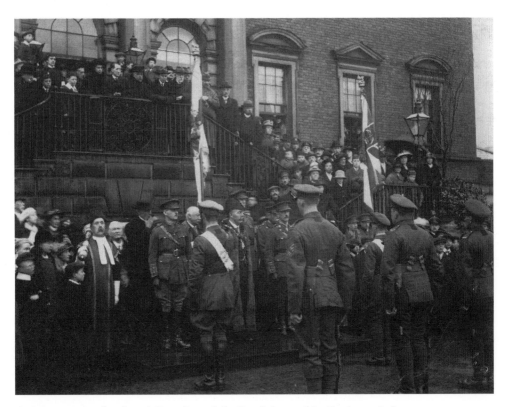

A civic reception for the 4th Battalion of the South Lancashire Regiment in June 1919.

kennels of Lamsdorf … imagine our delight when on our arrival there we encountered British officers who had been sent to deal with the repatriation of prisoners.

However, many returning Prisoners of War and those who served on the various battlefields of the First World War never spoke to their families about their experiences. Many were changed forever by their experiences and some were undoubtedly suffering from shell shock or (what would be later recognised as) port-traumatic stress. As well as trying to re-adjust to civilian life the returning service men found that most of them were eligible to vote for the first time in the upcoming General Election and many women also had a political voice. The Election came to be called 'the khaki election,' because the result could be seen as verdict on the Coalition government's handling of the campaign by those who had sacrificed the most. While Lloyd George was returned as Prime Minister the Liberal Party nationally lost support to the newly organised Labour party. Perhaps surprisingly given Warrington's status as an industrial town the Conservative candidate, Harold Smith, was returned with the largest majority in the town's electoral history, defeating the Liberal candidate, Sir Peter Peacock who had been Warrington's mayor throughout the war years.

Although Warrington was still trying to return to normality the war did not officially end until 28 June 1919 when both sides signed the Treaty of Versailles. The town received news of the event on 2 July and there were impromptu celebrations, rather

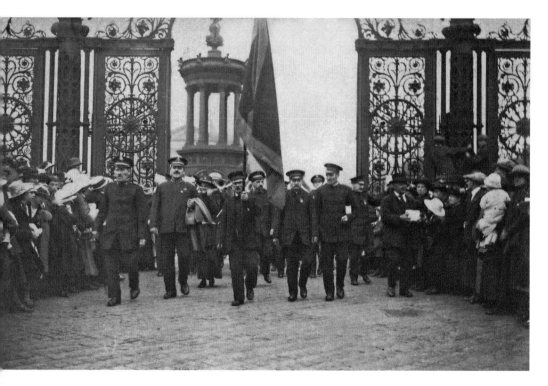

The Salvation Army at the 1919 Peace and Victory Walking Day.

more muted than on Armistice Day, even though flags were raised around the town. The *Warrington Examiner* reported that, 'the town was kept well alive and merry making went on until well after midnight'. Not surprisingly soldiers took a lead role on the occasion and especially in letting off fireworks with abandon.

> Shortly after six o'clock a party of wounded Tommies let of a couple of cannons at Market Gate. They burst with a report like a clap of thunder, and the people scattered in all directions. Shops in the town where fireworks could be purchased began to do a roaring trade. Fireworks were thrown indiscriminately in the air and one daring youth even applied a match to a cannon and threw it at the feet of a policeman on point duty.

The *Warrington Guardian* added that 'until midnight Sankey Street and Bridge Street presented a seething mass of humanity and there was much cheering, singing and general jubilation. Sailors and soldiers arm in arm and singing well-known airs made their way good humouredly through the streets.' Meanwhile it seemed the local police force also joined in the celebrations by choosing to ignore minor public order offences. The *Warrington Examiner* gave a vivid word picture of the noisy scene.

> Improvised jazz bands had been much in evidence, the soldiers creating much noise on any form of instrument, from a cornet which had seen better days, to penny squeakers and tin whistles. The members of one 'band' lined up four abreast and marched, headed by their much beflagged drum major – who brandished a walking stick with deft fingers – especially on innocent pedestrians who happened to stray too close. When the members of the real Salvation Army Band appeared in Sankey Street, collecting on behalf of their Walking Day treat, the jazz band immediately lined up in front of them and for the length of Sankey Street acted as an advance party. The police smilingly looked on throughout the whole of the proceedings, 'no doubt more keen on making their flag day a bumping success than running anyone in'.

Warrington was already in a celebratory mood with the revival of the town's annual Walking Day which had been cancelled during the war years. Warrington was in gala dress on Friday 4 July for what was dubbed 'Warrington's Great Peace Pageant.' The *Warrington Guardian* reported that, 'Walking Day was to the people of Warrington the happiest evidence conceivable that the era of peace has returned'. The event would go down in history as the Peace and Victory Walking Day.

> Never has the town more fully recognised the greatness of an occasion. The patriotic note was strongly in evidence. Most of the schools had their displays of red, white and blue devices in flowers or decorative material, whilst not a few of the children were picturesquely costumed to represent the Allied nations.

A nation-wide peace celebration was planned for the August Bank holiday weekend which was then held at the beginning of the month. This concept was revised to give local freedom to plan the programme and in Warrington this began on Saturday

An effigy of the 'Kaiser Bill' is hung at the 1919 Victory celebrations.

19 July which was dubbed Peace Day and culminated with an event on 15 August called Children's Peace Day. There were a series of events across the town and with specific target audiences (described in less politically correct terms than today) as cripples day and aged people's day!

As the *Warrington Examiner* reported,

Saturday 19 July will go down in history as the day on which the world rolled on from the horrors of war to the course of a new peace era ... Warrington is thankful and joyous that we have peace once more. There were more Union Jacks exhibited than ever before; there was gaiety in the streets without horse play or rowdyism and the children made it a general joy day. Many formed bands with tin cans, steel helmets and whistles as instruments and paraded the streets attired in the discarded and distorted uniforms of their ex-soldier relatives. In the morning when the church

bells rang joyfully, the town appeared as it does on Sunday mornings ... more in accordance with the great peace than if the carpenters, joiners, seamstresses etc had been hammering away or putting the final touches to the decorations along the route of a pre-arranged procession. In the afternoon the town became more lively and in the evening there was plenty of a rather boisterous but good humoured fun. Motor cars and other vehicles were decorated in flags; streamers were suspended from many buildings and fireworks were let off in various thoroughfares.

There was a treat for the infirm from 2.45 p.m. to 6.45 p.m. Bank Park was closed to the public for a reception of blind, crippled and deaf people who were entertained by the Salvation Army Band and performers from the various theatre productions in the town.

The celebrations were not confined to the centre of Warrington as every surrounding village took part. At Croft there was 'Procession, Pageant, Sports, Dancing, Bonfire and Firework display'. The procession featured a lorry carrying a figure of the Kaiser in chains which was later burnt on the bonfire. While at Lymm,

> The steps of the cross were thronged with little ones; an open square in front was lined on two sides with older children, whilst the fourth side lay open, reserved for the gallant men in whose honour a crowd of townspeople had attended. The air was merry with the music of the church bells and of the village band.

Stockton Heath held a united Thanksgiving Service and procession and tea and sports for the children. The procession around the village passed in silence near to the Stockton Heath end of Ellesmere Road where a Union Jack hung at half-mast, below which hung a wreath of laurels, together with a card bearing the words, 'Salute the Fallen'. After the procession the children were regaled with a substantial tea, then enjoyed the games, sports, donkey rides and other fun of the fair provided for them on Wilderspool Park. Unfortunately Master Probert of Ellesmere Road fell heavily in the high jump and broke his ankle but hopefully he recovered in time to attend the climax of the village events, the Monday night bonfire. In accordance with his promise to the children at the time of the Armistice, Mr John Hallows arranged a bonfire on the spare land in Alexandra Park. On the top of the pyre was an effigy of 'Kaiser Bill' bearing a card with the words, 'I will Rule the World'. The fire burnt fiercely and well and the large crowd cheered heartily as it blazed away.

On 9 August the Peace Celebrations continued with a Victory march for ex-soldiers and sailors in Bank Park; a procession to a sports event at Wilderspool Park and fireworks. The march passed a Cenotaph which had been erected on the Cheshire side of Warrington Bridge. The procession was headed by ex-service men from the fire brigade who rode on a fire engine which had a floral Union Jack on the front. All the ex-service men on the march bared their heads as they passed the Cenotaph which was: according to the *Warrington Examiner*, 'a purple and black draped dais surmounted with a black marble cross with the Union Jack draped around the bottom and bearing two magnificent laurel wreaths'. It bore the inscription, 'In memory of

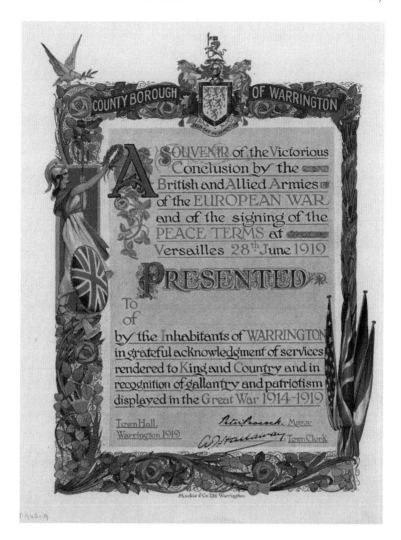

A certificate sent to those who had contributed to Warrington's war efforts.

the glorious dead. He gave his heart to his home. He gave his life to his king and his country and his soul to his god.'

The cenotaph was visited by thousands of people. The site chosen for it was thought to be the most appropriate, practically at the junction of five leading thoroughfares in an open and central space where it was conveniently accessible from all parts of the town and conspicuous to those travelling through. The Cenotaph remained in place until Tuesday and was covered with flowers and wreaths which were later taken to the Soldiers Corner at the Cemetery.

The Children's Peace Day on Friday 15 August 1919 marked the end of the official Warrington Peace Celebrations and involved all elementary children in an event like Warrington Walking Day. The morning was a holiday and after dinner all the children marched to the Town Hall and assembled on the lawn under bright blue skies and a blazing sun. All the children wore a medal presented to them on the

previous day. The Mayor made a speech praising the children's contribution to the war effort,

> May I thank all the children of Warrington, because although you did not go in the battleships and on the fields of Flanders, you fought the battle in this great country. The girls have done a lot of work and both boys and girls have given their pennies to the various War Funds. I shall always remember the handsome amount the schools contributed to the Prisoners of War Fund to help the South Lancashires.

The children then marched off to Victoria and Bewsey Park for sports and limited refreshments. The town's celebrations and commemorative events were now officially at an end and the focus would move to more permanent reminders of the sacrifice Warrington's families had made during the First World War.

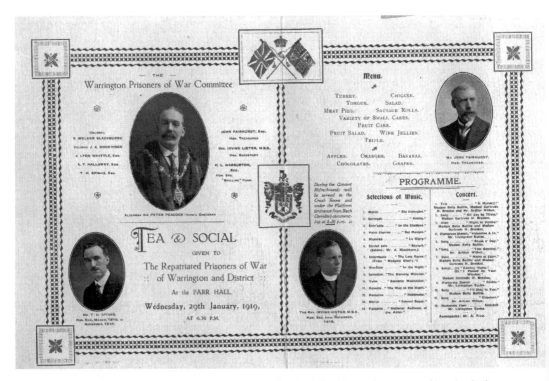

A reception for prisoners of war at the Parr Hall, which had been the centre of local relief efforts during the war.

CHAPTER 9

WE WILL REMEMBER THEM

Even before the war had ended, the people of Warrington wanted to pay tribute to those who had been killed in action. Mothers and widows could not visit a grave of their loved one so the idea of local war shrines or memorials engraved with the names of the fallen was chosen to give communities a focus for their grief.

In January 1917 Peter Peacock, the Mayor of Warrington, represented the town at the first official public ceremony, unveiling a Roll of Honour outside the home of Mr and Mrs Harry Kent of No. 42 Hoyle Street. Their son Harry, a soldier in the

Mayor Peter Peacock unveils the Bewsey War Shrine in January 1917.

Gordon Highlanders who was killed in November 1915 had been the first Bewsey soldier to die in action. The Roll of Honour listed the 180 men from Hoyle Street, Lilford Street, Catherine Street, Pierpoint Street, Pitt Street, Albert Street and Edward Street who had been on active service up to that date. Of those twelve had been killed in action or later died of their wounds.

It was a stark reminder of the impact of the war on each small Warrington community and to one of the veterans at the ceremony it brought back the reality of what each man had sacrificed. The *Warrington Examiner* recorded his poignant memories.

> My mind travelled back to a day ... when we were making our way towards the mud and blood of Flanders ... The majority of us knew nothing of war as it really is but there on the edge of a recently ploughed field, stood a little wooden cross, made in the rudest fashion of two strips of matchwood nailed together and half buried in the earth. It was with something of a shock that we realised we were passing a soldier's grave ... and the remains of one, who a few months before had been as strong and healthy as ourselves ... The Supreme sacrifice of one who laid down his life for his country came home to us only too vividly ... (At this Service) I was lost in the thought of those of my own comrades whose graves are not even marked by a wooden cross, since most of them fell during a heavy battle, and whose memory will be ever green to me as will those twelve in the Bewsey district to their relatives and comrades.

Orford Hall was bought as a memorial to the valour of the lads of Warrington in the First World War.

Private Edwin (Teddy) Johnson with his fiancée Leah. He was killed in action at Cambrai on 22 March 1918 and his heart-broken fiancée declared that she thought 'the sun would never shine again'.

Peter Peacock also officiated at the official opening of Orford Hall in August 1917, which had been bought by the council from the Blackburne family as a memorial to the lads of Warrington in the First World War. At the opening the Mayor Peter Peacock said,

> After the war the council will formulate a scheme for the use of the hall and grounds. In the meantime the grounds will be open to the public for rest and recreation. The grounds will be open from today and the old and young people will spend many happy hours in this quiet and pleasant place. The fields behind the hall have already been thrown open as a playground for the children and I imagine the place one day laid out with bowling greens and permanent allotments. The large pond in the rear (part of the old duck decoy) will be an endless attraction to the children and when it is made safe for their use will be a fine place for paddling and for catching stickle backs.

For many Warrington families this idyllic vision was overshadowed by the loss of a loved one on a foreign battle field and without the consolation of a local grave to visit. George Whitfield's father was one of the few Warringtonians who made the poignant journey overseas to see his son's grave with its temporary wooden cross.

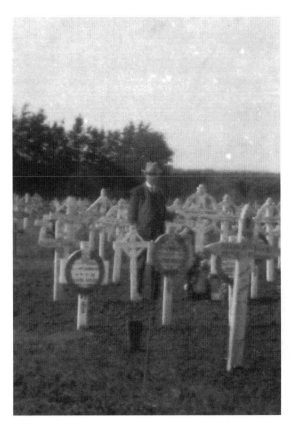

George Whitfield stands by his son's grave. Later the wartime cemeteries of the casualties of the Western Front would be taken over by the Commonwealth War Graves Commission and these temporary markers would be replaced with permanent headstones.

Often the only tangible remains of the family's sacrifice were the memorial death plaque they received, together with the serviceman's medals. A soldier who had served from the early campaigns of 1914 was eligible to receive three medals; the 1914 or 1915 Star; the British War Medal and the Victory Medal, which were designed to be worn together and in that order left to right. The group of medals were popularly known as Pip, Squeak and Wilfred. They got their nickname from a Daily Mirror cartoon strip which was popular at the time the medals were issued and which featured a dog called Pip, a penguin called Squeak and a rabbit called Wilfred.

However, as George Whitfield's father discovered the military authorities were overwhelmed by the logistics of dealing with war pensions and sending out medals and memorial plaques. On 31 January 1921 he received George's British War medal but discovered it incorrectly described him as a private rather than as a lance corporal. In July 1921 he wrote to the officer in charge of the battalion's records asking for the progress in getting the memorial plaque as others in the district with relatives killed after George had already received their plaque. Mr Whitfield was clearly educated enough to deal with the military bureaucracy he encountered, but many others grieving for their loved ones would have found the prolonged situation extremely distressing. Many ex service men who had survived the First World War consigned their medals to a drawer as an unwelcome reminder of their experiences.

Right: Memorial plaque for George Whitfield. Designed by E. Carter Preston, the design depicts Britannia with a lion. The plaques were sent to the next of kin of those killed in action between 4 August 1914 and 30 April 1919. As so many were issued, they were popularly known as a 'dead man's penny' after the penny coin of the day which was very large but almost worthless.

Below: Ex-service men wear their war medals with pride at the military funeral of First World War veteran, Major Boast in 1930.

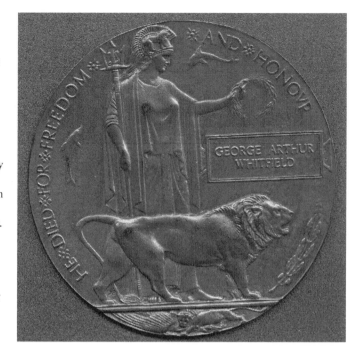

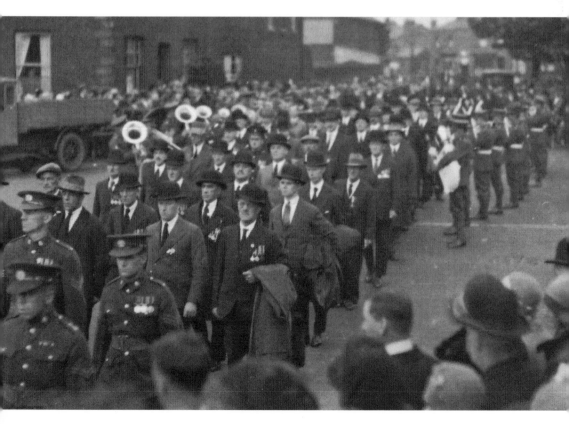

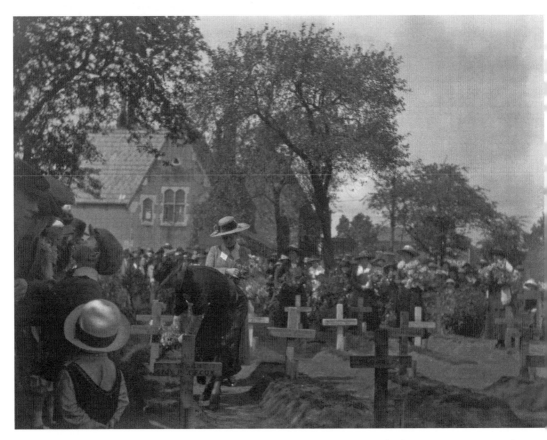

The first graves at Soldiers' Corner at Warrington Cemetery with their temporary simple wooden crosses.

In January 1920, Warrington gained a visible memorial to the legacy of the First World War with the arrival of a Mark IV tank at a siding at Bank Quay Station. The *Warrington Examiner* described it rather poetically as 'His Majesty's Landship 139' and reported how it had to be manoeuvred off the train and via Wilson Patten Street to Victoria Park watched by an interested crowd. The tank's journey was not without incident:

The tank slid round like a turtle, and with much grunting and coughing waddled in the direction of Bank Quay station. At the corner of Bold Street it stopped dead, swung round, crawled a short distance, and again came to a standstill. Flames a yard long were spitting from the engines and the passengers were advised to alight. The tank was able to continue and was greeted by a large number of people at Warrington Bridge. The journey along Knutsford Road was more or less uneventful. As the tank rattled along windows were thrown open, heads were thrown out and people rushed to their doors to witness the passing of what was to most of them a novelty. On arrival at Victoria Park, 139 paused, turned easily round and with a few snorts sidled onto the chosen ground.

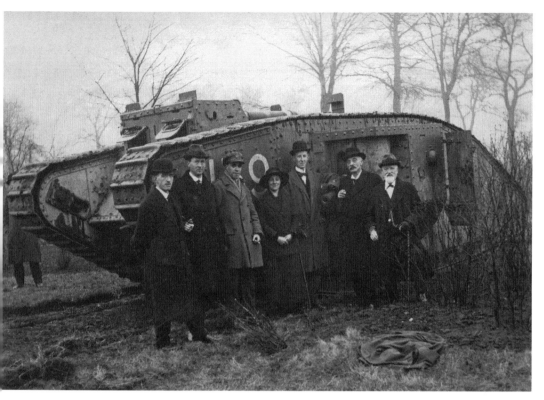

Warrington's tank was presented to the town in January 1920 by the National War Savings Committee in recognition of the town's generous financial support for the war effort.

There the tank would remain until the early years of the Second World War when it would be dismantled and donated to the drive for scrap metal to create new weapons of war.

Once the excitement of the tank's arrival had worn off the town's attention turned to honouring the memories of those who had died rather than preserving weapons of the conflict. The bodies of many British men who died in action were never recovered from the battlefields of the Western Front and they were later recorded on monuments such as the Menin Gate at Ypres or the Thiepval Monument on the Somme. However, there was no similar memorial for those who had died in other theatres of the war.

In 1920 the British Government proposed that the body of an unknown soldier, sailor or airman should be interred in Westminster Abbey to symbolise all who had sacrificed their lives for the country but had no known grave. Eventually a small number of bodies were exhumed from the sites of the major British battlefield areas of the Western Front and taken to a chapel in Northern France where the coffins were draped with Union Jacks. The commander of British troops in France and Flanders, Brigadier General L J Wyatt (who had his own connections with Warrington) selected one at random. The chosen body was taken to be interred in the Tomb of the Unknown Warrior at Westminster Abbey on 11 November 1918 on the second anniversary of Armistice Day. Earlier that morning King George V unveiled the Cenotaph memorial

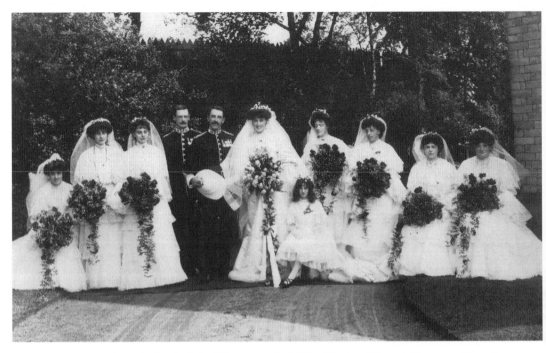

In June 1904 Captain Louis John Wyatt married Miss Marion (Gypsy) Sloane at Daresbury church. By the end of the First World War as Brigadier General Wyatt he selected the Unknown Soldier to be buried at Westminster Abbey.

in Westminster at eleven o'clock. The nation paused for what would become the customary two minutes' silence.

However, there were no wreaths of red poppies on this occasion. The red poppy was adopted by the British Legion in 1921 as a symbol of remembrance of the First World War and a way to raise funds for disabled veterans. The poppy had been chose as a reminder of the splashes of red poppies which stood out amid the barren muddy battlefields of France and Flanders and symbolised the soldiers' blood spilt there. The poppy seeds had lain dormant for years until they were disturbed by the chaos of battle and burst into life. Later, in 1933, the Women's Co-operative Guild introduced the white poppy as a symbol of peace but many veterans saw it as anti-war and disrespectful to those who had given their lives in the First World War.

It was important for Warrington families to have a visible monument locally they could visit so districts and workplaces around the town began to set up their own war memorials around the town. One of the earlier memorials was dedicated to railway workers and was unveiled at the important base of Dallam Shed in August 1921. The event took place at in the presence of the Rector of Warrington, Rev. F d'Anyers Willis and was unveiled by Mr F.W. Dingley, chief locomotive running superintendent with over 1,000 attending the ceremony. The *Warrington Guardian* explained that, 'No branch of the services performed more heroic service than did the drivers and firemen of the hospital, munition and commissariat trains which ran through the danger zones

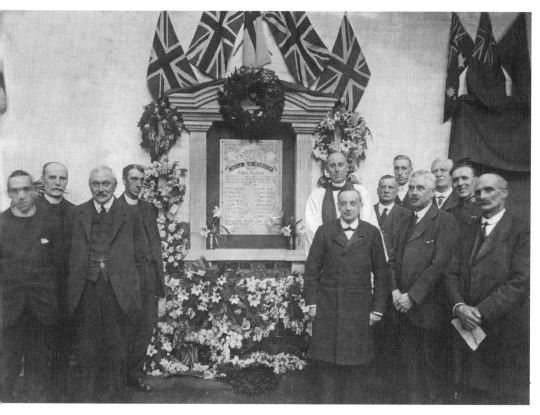

Unveiling of the Memorial to Railway workers at Dallam Shed 30 April 1921.

of the Ypres Salient, on the Somme Front and in March 1918 in the neighbourhood of Amiens.' The *Warrington Examiner* added that,

> The memorial takes the form of a handsome brass tablet and is situated on the south wall upon a polished slate background bordered by artistic Runcorn sandstone. On Sunday morning the memorial was decorated with the Allied flags, draped with thick purple covering. The railway shed had been richly beautified.

Many of Warrington's communities had begun to erect their own local memorials. One of the earliest was at Padgate and in June 1919 the *Warrington Examiner* reported that William Bennett had offered land for a park and war memorial near Padgate Station but after his death his eldest son Arthur Bennett brought the plan to fruition. On 2 July 1922 the war memorial was officially unveiled at the centre of a 5 acre park presented by the late William Bennett as a thanksgiving for the Great Peace. The Bishop of Liverpool and a contingent of the South Lancashire Regiment were present. The memorial was 22 foot high obelisk in the Roman style designed by Capt. F. Jardine Barnish. The names of the fallen were engraved on either side of the obelisk in gold lettering on panels of Westmorland green slate.

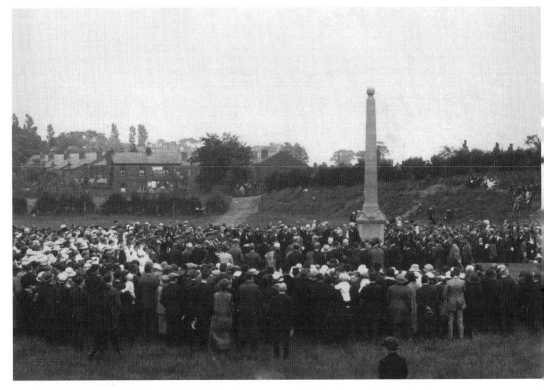

The unveiling of Padgate War Memorial July 1922.

In 1921 the Town Council set up a War Memorial Committee to establish Warrington's main memorial in a prominent place at Bridge Foot. This was eventually unveiled in November 1925 as the focus of the town's annual commemorations.

Although some of the works' war memorials did not survive the late twentieth century decline of the town's heavy industries and demolition of factories many of Warrington's surviving war memorials remain and provide invaluable clues for those hoping to trace their family's stories of the First World War. This book could not hope to document the part played by all the Warringtonians who played their part on active service or on the home front. For many researchers family papers and photographs or an ancestor's war medals are the best starting point. However, the town's official records in Warrington Museum and Local Studies collection together with online records will help in tracking down the town's war heroes.

Warrington Archives and Local Studies collections hold microfilm copies of accounts of deaths and casualties in the two main local newspapers of the day i.e. the *Warrington Guardian* and the *Warrington Examiner*. Another useful source is the 'Warrington War Heroes' collection of copies of newspaper clippings extracted from the *Warrington Guardian* between 1914 and 1919. These articles cover deaths, injuries, medals, commendations, prisoners of war, and missing soldiers. The collection is indexed by name of the soldier, and separated out into three sections, the South

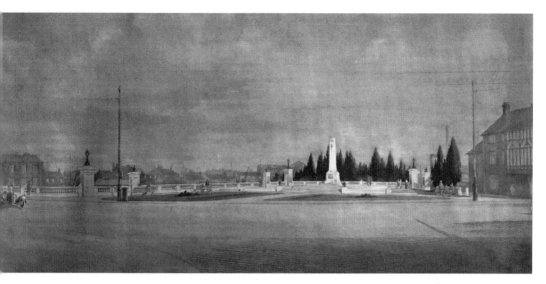

The Warrington Cenotaph ,a simple thirty foot high granite obelisk, was unveiled in November 1925. The memorial was appropriately sited at Bridge Foot, the scene of many battles in Warrington's past.

Lancashire Regiment, the Cheshire Regiment, and Miscellaneous Other Regiments. The people mentioned in the *Guardian* are likely to only be those with a connection to Warrington. As with any newspaper report, the information within these articles may not be completely accurate.

These local records can be used alongside records found on the internet including military records on the Family History sites. These include service & pension records and lists of medals awarded. The information held within the service record usually includes: the serviceman's name, age, place of birth, occupation on enlistment, marital status, regimental number, date of attestation (enlistment) and physical description. Unfortunately about sixty percent of the original soldiers' Service Records were destroyed during an enemy bombing raid in 1940 during the Second World War. Roughly two million records were saved, these are now known as the 'Burnt Records'. This means there is only a forty percent chance of finding any surviving records for some soldiers. However, those lucky enough to discover a service record may find it includes medical history forms; records of injuries or disability statements; regimental conduct sheets; awards and discharge documents.

Quite often a soldier lied about his age when he enlisted and may even be described by a different first name on his service records so it is always a good idea to use other records such as the Census returns to cross-check ages, find correct names, ages and addresses as well as death records and other sites such as The Commonwealth War Graves Commission listings.

However, although the *Great War* represents the end of many Warringtonians' story, for countless others the post war years proved equally challenging and almost inevitably shaped by the traumatic events of 1914–1918.

CHAPTER 10

POST-WAR WARRINGTON

Warrington had barely had time to celebrate the coming of peace when prominent figures began to lament that society had broken down during the war years in the absence of male authority figures. On 8 March 1919 the *Warrington Guardian* lamented the age-old problem of young people, presumably those who were too young to have been conscripted. The paper complained that, 'Sankey Street is a disgrace to the town by reason of night scenes, the promenading and the coarse class of rowdyism which goes on there throughout the week and reaches a dreadful climax on Sunday night.'

In February 1919 the Bishop of Warrington, Dr Linton Smith, spoke of the breakdown of moral values in society caused by the war.

> When a family man was away from home the main element of control disappeared and often the children were inclined to run riot and regard themselves as free from control. The result was a great laxity of moral conduct. Also the segregation of a large number of men during the war away from their homes and the softening wholesome and sane influence of family life had undoubtedly tended towards a giving way to passion and vice which would not have been the case had they been within home conditions.

However, his greatest concern was what he described as an outbreak of *khaki fever* on the part of the girls.

> He was sorry to say that standards of honour and purity amongst much of the girlhood of the country had fallen seriously low during the war, because of the freedom of the girls which the war had brought about.

His female diocesan secretary was equally scathing about her own sex, declaring that,

> The problem of the girls was one of the greatest problems of the coming reconstruction … not only the munitions girls, but girls of every class of society who now had such an utterly different outlook than in the past. They had an independent spirit of adventure, recklessness and a high spirit of desire to live and get the fullness out of life.

After the Armistice women quickly realised they were expected to step aside and let men take over the jobs again. Women had found themselves regarded as honorary men for the duration of the war but now the majority were expected to return to their subservient role as 'little wife and mother'. However, for many women marriage was no longer an option since they had lost their sweethearts during the war. Some of the more educated women were reluctant to relinquish the opportunity of useful employment they had found in wartime even if they did not need to work to earn a living.

Countess Ferrars advised many of the volunteer nurses that they might find an outlet for their talents as healthcare workers or in maternity, especially working with poorer mothers. She observed that,

> Conditions had altered as a consequence of the war and many more women would in the future have to earn their living than had previously been the case. If any who were not compelled to earn their living took a salaried position they would have to obtain a full rate of pay so as not to compete unfairly … while those who did voluntary work would have to maintain the same standard of efficiency as if their livelihood depended on it.

However, many women were not selfishly retaining a job but were now the sole bread winners as widows or with a man unfit for work and to maintain his family. Women munitions workers were swiftly made redundant. A return to domestic service was

After the war many women had to return to domestic service.

seen as the answer for women who needed to work even though wages were generally lower than those they had been earning in the war factories. Unemployed women who refused jobs in domestic service had their benefits withdrawn and they were removed from the unemployment register. In March 1919 the *Warrington Guardian* published a letter from the Women's Legion, an independent philanthropic institution, on the problems of getting domestic servants.

> On every hand we hear the cry of housewives who require maids and domestic helps but cannot obtain them. Meanwhile girls from war factories continue to be discharged in thousands. In Warrington out of about 2,000 unemployed, over 1,600 are women and 300 girls. To some extent it is their own faults. After receiving high war wages girls are naturally reluctant to accept work which they think less advantageous ... Meanwhile for thirteen weeks they can draw unemployment pay.
>
> Not all girls are so foolish to despise domestic service, however, of the numbers who have found work, the number of domestics is nearly as great as the commercial and clerical professions, engineering, textile and dressmaking trades, general labour, food, drink and lodging occupations put together ... There is nothing degrading in domestic service.

However, it was not only Warrington's women who found themselves unemployed in the post war economic trade slump. By the autumn of 1921 mass unemployment was becoming evident in the town as Charles Dukes had prophesied in 1914.

> What are we to expect when the war is over? ... When those hundreds of thousands of men return from the front, and if their employers keep their promise and give them their jobs back, someone will have to get out. Trade cannot be immediately restored and chronic employment will have to be faced ... Needless to say, the general labourers and semi-skilled workers will be the greatest victims from unemployment and wages depression.

In early September there were reports in the local press of a demonstration of some of the 15,000 unemployed and short time workers after payment of the dole was stopped and single men were told they would need to enter the workhouse instead. As the issue was debated at the Town Hall, Cllr Plinston (Labour) stated that: 'The proportion of ex-Servicemen among the unemployed was 65 or 70 per cent. Those men had gone through much in serving their country and the country ought to accept the responsibility for them and their dependents.'

The unemployed were ripe recruiting ground for the Labour Party as local Labour stalwart Harry Hardman later explained.

> During the First World War we were going to have a country fit for heroes to live in. That was part of the propaganda to recruit men into the army. The trade unions had been accepted in 1914–18 by the establishment, instead of fighting them to get the war won. Trade union membership went through the roof. Firms were giving them

facilities to get the war won. The reality was after the war was over they were trying to push everybody back to square one. Millions were unemployed again in the early 1920s. Lads stood on the street corners, arms off, blinded by the war, begging ... When you got the reality, back to unemployment, back to poverty, rickets, tuberculosis, all diseases of poverty – then the lads knew that the score would say, a land fit for heroes to live in? You've got to be bloody heroes to live in it!

During the war housing construction slumped leading to a housing shortage, overcrowding and unscrupulous landlords profiteering by raising rents and during the war years Warrington had seen the crisis lead to rent strikes. Even when the government stepped in to regulate rents many landlords neglected to carry out repairs.

The poor condition of working class housing had become a concern during the war, not for humanitarian reasons but because it was alleged that bad housing was responsible for the poor health of many working class recruits who failed their medical examination. A promise to build 'homes fit for heroes' was a key pledge of the 1918 'Khaki Election' and resulted in the 1919 Housing Act. Although nationwide this pledge was soon ignored, Warrington took advantage of the government loans available to build new council estates largely though

Bewsey Garden Suburbs.

the influence of Conservative councillor Arthur Bennett who was determined to improve slum housing in the town.

The Housing Act of 1919 compelled local councils to build good houses and allowed them to borrow money to achieve this. All the houses built with these loans had to follow strict guidelines to ensure that every builder would produce houses of the same size and quality. Warrington Borough Council began to buy up land to build new council housing estates, beginning on a smaller scale with houses off King Edward Street before undertaking the more ambitious Bewsey Garden Suburb. Here, according to the *Warrington Examiner*, they planned to build,

> Five hundred and fifty houses of three types, parlour, two bed-roomed and three bed-roomed houses … according to the plans prepared by the Borough Surveyor, Mr Andrew Ker. In the centre of the estate will be bowling greens, tennis courts and playing grounds. On the other side of Lodge Lane there will be an elementary school, and intermediate school and a special school for children. There will also be playing fields for the secondary and elementary schools. Councillor Plinston (deputy chairman of the Housing Committee) said he was a great believer in the power of the environment and he knew that the houses and overcrowding with all the attendant evils, had caused in Warrington, more ill health, misery, matrimonial troubles, and other troubles and other difficulties than any other factor they as a Council, had to deal with.

When Bewsey Council Estate opened in 1927 it was seen as an idyllic place to live away from the smoke and grime of old Warrington's factories and the rows of poorly constructed terraced houses which surrounded them. It was designed with the needs of the new community in mind with well built houses, leisure facilities and schools, in fact everything that families would need in suburbia. Warrington's council estates were a major legacy of the post war construction and thanks to the influence of Arthur Bennett the town had been more far-sighted than many of its neighbours.

As the post war trade slump deepened Warrington's traditional political parties of Conservatives and Liberals were determined to maintain the pre war political establishment and were prepared to take on the threat from the Labour party. Lady Greenall continued to be a stalwart campaigner for the Conservative party and while the Broadbent sisters remained firm supporters of the British Red Cross Society in the post war years they also turned to politics. Eldest sister Constance became Warrington's first female councillor in 1920, defeating Charles Dukes to represent the Latchford Ward. She won a sweeping victory in a by-election which had seen Conservative, Liberals and women voters unite against a left-wing Labour candidate who many still regarded as unpatriotic for his war time stance. A former soldier who was one of her supporters, declared that it had been his privilege again to fight for his country and that the Bolsheviks and extremists were a bigger horde of corruption than ever the Germans were. The Broadbent sisters came to share his views and by the early 1930s their fear of communism would see them move to support far right political views.

Margaret, Lucy and Sylvia Broadbent continued their work for the British Red Cross after the war.

Charles Dukes was undaunted and in the general election of 1923 was returned as MP for Warrington for the first time. His parliamentary career was relatively short lived but his trade union career flourished and by 1946 he was President of the Trade Union Congress. In 1947 he was elevated to the peerage as Lord Dukeston, to the disgust of Harry Hardman who remarked, 'God forgive him; I won't!'

Meanwhile George Crosfield took a less overtly political stance by being a leading figure in an organisation known as FIDAC, the *Federations Interalliee des Ancien Combattants* (or the Interallied World War Veterans Association). The philosophy behind the movement was that soldiers of all sides who had experienced the terrible reality of trench warfare could use their experiences to influence politicians and prevent another war. Organisations such as the British Legion and the League of Nations hoped that by working with peace parties in Germany and Austria they could prevent Germany re-arming and seeking revenge for the harsh peace conditions imposed by the Treaty of Versailles.

In May 1926 Lieutenant Colonel George Crosfield visited America at the invitation of the American Legion in his role as President of FIDAC and was received by

Sir Gilbert Greenall was given a peerage for his war-work and his wife Lady Daresbury wore her official robes with pride.

Lt Colonel George Crosfield (front row far right) meets President Coolidge (centre) at the White House on his tour of America in 1926.

President Calvin Coolidge at the White House. Described perhaps generously by the American press as a 'British war hero' or alternatively as 'the one-legged hero of St Eloi', Crosfield was feted as the representative of 8 million war veterans. The President expressed himself greatly interested in Crosfield's stark warnings of the startling figures of Germany's preparations for war. Crosfield indicated that in a few months Germany could become a real military menace, with a nucleus of 200,000 trained fighting men, 2,000,000 of her youth generally trained in military tactics and with her huge industrial plants intact and ready to turn out shells and munitions on short notice. Crosfield's plea to a meeting of American Legionnaires was for,

America to stand with the Allies in 1927 as she did in 1917. The crying need in Europe now is for the Allies to stand shoulder to shoulder in unbreakable

alignment ... We veterans who fought together ... must show that FIDAC and its member organisations are out for peace – not peace at any price: not war at any price – but justice at any price. We must show the red-flagged communists that our countries are no places for them – that FIDAC will oppose them at every turn ... By our might in standing shoulder to shoulder in peace time as we did in war time, we can convince the world that while we live there can be no more war, nor can there be another holocaust during the lifetime of our children. That is our guarantee.

Tragically Crosfield and his comrades in FIDAC were unable to make good this guarantee. In 1935 he was part of an ill-fated British Legion delegation to Germany, still hoping to stem the reawakening of German nationalism, declaring,

We must instil into the minds of the rising generation that while they must love their own country and always be ready to defend it that is no reason why they should hate other countries! They must learn too that war is in the highest degree cruel. Who is there in any nation who wants another Verdun, another Somme, or another Passchendaele, another gigantic orgy of hate and passion which makes justice and right thinking fly to the four corners of the world?

Hitler expressed his appreciation for the initiative of the British Legion after a private meeting with them and Crosfield and his British Legion colleagues were regarded as naive for believing that Hitler's policies would not lead to war. The policy of appeasement towards Germany was doomed to failure.

In 1913 Warrington had welcomed a royal visit by King George V and twelve months later saw the country plunged into a devastating war. In 1938 the town celebrated a royal visit by his son King George VI and a year later saw history repeat itself with the outbreak of another world war. Tragically, Warringtonians who had lived through the traumatic events of 1914–19 were soon to realise that, despite all their sacrifices, the First World War would not, as had been alleged, be 'the war to end all wars'.